ROXY PAINE *Second Nature*

Joseph D. Ketner

Lynn M. Herbert

Gregory Volk

Contemporary Arts Museum, Houston

The Rose Art Museum, Brandeis University
Waltham, Massachusetts

ROXY PAINE *Second Nature*

LENDERS TO THE EXHIBITION

Charles Betlach II

James Cohan Gallery, New York

Robert Conn and Ann Hoger

Christopher Grimes Gallery, Santa Monica

Jeanette Kahn, New York

Private Collection, New York;
courtesy James Cohan Gallery, New York

Private Collection; courtesy Ronald Feldman
Fine Arts, New York

This catalogue has been published to accompany the exhibition
Roxy Paine/Second Nature, co-organized by Lynn M. Herbert, Senior Curator,
Contemporary Arts Museum, Houston, and Joseph D. Ketner, The Henry
and Lois Foster Director, The Rose Art Museum, Brandeis University,
Waltham, Massachusetts.

THE ROSE ART MUSEUM, Brandeis University, Waltham, Massachusetts
April 25–July 14, 2002

CONTEMPORARY ARTS MUSEUM, Houston
October 19, 2002–January 12, 2003

The exhibition's presentation at The Rose Art Museum
is sponsored by Sandra and Gerald Fineberg.

The exhibition's presentation at the Contemporary Arts Museum
has been supported by the Museum's Major Exhibition Fund contributors:

MAJOR EXHIBITION FUND

MAJOR PATRON
Fayez Sarofim & Co.

PATRONS
Mr. and Mrs. A.L. Ballard
Mr. and Mrs. I.H. Kempner III
Ms. Louisa Stude Sarofim
Susan Vaughan Foundation
Mr. and Mrs. Michael Zilkha

BENEFACTORS
Robert J. Card, M.D./Karol Kreymer
George and Mary Josephine Hamman
 Foundation
Max and Isabell Smith Herzstein
Rob and Louise Jamail
Stephen and Ellen Susman

DONORS
Eddie and Chinhui Allen
Andersen
Baker Botts L.L.P.
Mr. James A. Elkins, Jr.
KPMG LLP
Ransom and Isabel Lummis
Lester Marks
Jeff Shankman
Shell Oil Company Foundation
Leigh and Reggie Smith
Mr. and Mrs. Wallace S. Wilson

The exhibition catalogue is supported by The Brown Foundation, Inc.

cover: Scumak S2-P2-R12 (detail), 2001. Linear low-density polyethylene, 15 x 20 x 24 inches.
 Courtesy the artist and James Cohan Gallery, New York
p. 1: Joshua Tree National Park in southern California, photograph by Roxy Paine
pp. 2–3: PMU NO. 8 (detail), 2002. Acrylic on linen, 36 x 59 x 2 1/2 inches.
 Courtesy the artist and James Cohan Gallery, New York

Library of Congress Control Number 2002090632

ISBN 0-936080-74-4

Distributed by:
Distributed Art Publishers, Inc. (D.A.P.)
155 Sixth Avenue
New York, New York, 10013
212/627-1999
www.artbook.com

Contemporary Arts Museum
5216 Montrose Blvd.
Houston, Texas 77006-6598
phone: 713/284-8250
fax: 713/284-8275
www.camh.org

The Rose Art Museum
Brandeis University, MS 069
P.O. Box 549
415 South Street
Waltham, Massachusetts, 02454-9110
www.brandeis.edu/rose

CONTENTS

It is with great pleasure that we present *Roxy Paine/Second Nature* to viewers in Massachusetts and Texas, and through this accompanying publication, to wider audiences. A project that has grown from a shared interest and commitment to the work of this important and provocative artist, this exhibition reflects the mutual curatorial interests of our two institutions, combined here to share strengths and resources. The Rose Art Museum and the Contemporary Arts Museum have long been dedicated to the art of our time, to sharing with audiences—both the informed and the less experienced—the work of today's artists.

Joseph D. Ketner, the Henry and Lois Foster Director of The Rose Art Museum at Brandeis University, was first introduced to the art of Roxy Paine by Ronald Feldman who presented a seminal exhibition of the artist's work in 1997. This show featured the two bodies of work by Paine that form the core of the current exhibition. On a subsequent studio visit in the spring of 2000, Ketner first saw Paine's *PMU (Paint Manufacture Unit)* and realized the time was right for a full-scale exhibition. Concurrently, Lynn M. Herbert, Senior Curator at the Contemporary Arts Museum in Houston, expressed her own serious interest in the artist's work. The present collaboration evolved from this fortuitous timing of mutual interests.

At The Rose Art Museum, the exhibition has been made possible by the generous support of Sandra and Gerald Fineberg. General programming at The Rose is made possible by Accenture, Fleet Boston Financial, The Henry Luce Foundation and, Target, Inc. Their support is critical to the success of the Brandeis museum.

FOREWORD AND ACKNOWLEDGMENTS

In Houston, the exhibition is made possible by the foresight and generosity of the contributors (listed on page 4) to the Contemporary Arts Museum's Major Exhibition Fund that supports all projects presented in The Brown Foundation Gallery. The enlightened support of The Brown Foundation, Inc. makes all Contemporary Arts Museum publications possible and we are grateful for their support of our published scholarship and commitment to contemporary art and artists. General support for operations and programs is provided by the Houston Endowment Inc., the City of Houston and the Texas Commission on the Arts through the Cultural Arts Council of Houston/Harris County, and the Institute of Library and Museum Services.

The Rose Art Museum and the Contemporary Arts Museum are grateful to the enlightened individuals, foundations, corporations, and public agencies listed above for their support of the arts and for giving us the resources to serve our audiences.

Ketner and Herbert wish to thank James Cohan, Elyse Goldberg, Arthur Solway, and Eric Stern of James Cohan Gallery, New York, for their considerable and welcome assistance with the organization of the exhibition. They would also like to thank New York-based art critic and curator Gregory Volk for the insightful and energetic essay he has written for this catalogue. In addition, they would like to thank Katrin Pesch, Jack Muccigrosso, and Paulo Flores in Roxy Paine's studio for all of their assistance with this project.

Ketner and Herbert, as co-curators and organizers of the project, have

approached this exhibition in a most generous collaborative spirit—with great care for the artist's intentions—as the consummate professionals and scholars they are. The staff of The Rose Art Museum, which has been responsible for the loans, their assembly, and their transportation, has been instrumental in the successful accomplishment of the project. At the Contemporary Arts Museum, where we have produced this publication, we thank editor Polly Koch for her many contributions, and Don Quaintance and Liz Frizzell of Public Address Design for their collaboration and ever sensitive and careful attention to the spirit and reality of the artist's work in the design and production of this catalogue. We also wish to thank Peggy Ghozali and Leslie Cuenca at the Contemporary Arts Museum for their research assistance with the catalogue.

We are especially indebted to the lenders to the exhibition, listed on page 4, who have agreed to part with beloved and valued works of art for the duration of the exhibition in Waltham and Houston. Without them the project would not have been possible.

Finally, on behalf of all those who will be enriched by the experience of the exhibition and by contact with the publication, we thank Roxy Paine for his enthusiasm and commitment to this project, and for his engaging and intelligent mind, the force behind the work in the exhibition. He has shown us all new ways to think about art and life.

Marti Mayo
Director
Contemporary Arts Museum
Houston

Joseph D. Ketner
The Henry and Lois Foster Director
The Rose Art Museum
Brandeis University

Roxy Paine has been creating intriguing works of art over the past ten years. The artist began to attract considerable critical attention in 1997 when he exhibited two distinctive groups of objects—surrogate art-making machines and faux botanical specimens—at Ronald Feldman Fine Arts, New York. Over the past five years, he has developed these into a mature body of work that is the subject of this exhibition. Paine's machines and botanicals raise some poignant questions that are at the core of current cultural debate.

Curators and critics have christened Paine as one of the current generation of new media artists, including him in a number of important recent exhibitions.[1] Yet, such a classification limits the artist. The diversity of forms and meanings in Paine's work resists such a narrow definition. He has not chosen to pursue one medium to the exclusion of others, nor does he work in a particular style. Despite his diversity of "style," Paine's art does exhibit a consistent, if non-linear, conceptual unity.[2]

Paine explains that his art "is all about perception."[3] He is intensely engaged in an inquiry of how people perceive information and construct knowledge. He invents robotic art machines or faux vignettes of nature that force us to confront, or even alter, our preconceptions about art, machines, nature, and creation. In his formative text on the dawning media age, Marshall McLuhan recognized that, "the artist is indispensable in the shaping and analysis and understanding of the life forms and structures created by electric technology."[4] Paine is just such an artist. He draws upon a broad range of art and science disciplines to create works of art that investigate some of the fundamental questions confronting our culture at this critical moment of transformation from the mechanical to the information age.

INTRODUCTION

Joseph D. Ketner

Paine's art-making machines revisit the debate over the hand-made versus manufactured, ostensibly questioning the value of authenticity in art. In conceiving his first art-making machine, *Paint Dipper* (1996, fig. 22) Paine relished the irony of creating a machine that uses "the aesthetics and implementation of factory automation—streamlined, functional, precisely engineered and efficient—and applies them to something which is inefficient, non-functional, and inherently absurd."[5] Spectators cannot resist being mesmerized by Paine's massive *PMU [Painting Manufacture Unit]* (1999–2000, pp. 50 and 51) that automates an act previously cherished as the exclusive expression of the human hand and spirit. The robotic machine triggers a series of responses ranging initially from amazement at the spectacle, to the humor about the sexual overtones of the gushing hose, and finally to an uneasy angst as we witness a machine encroaching on a human endeavor.

Paine's "labor saving devices" deconstruct painting into its component parts by automating the creative process.[6] In earlier works including *Specimen Case* (fig. 1) and *Model Painting* (1996, p. 46), the artist dissected the brushstrokes of a painting, the supreme mark of individual expression. He molded them into individually sculpted components, as if producing a kit ready to assemble into a painting. Whether they are the painting, drawing, or sculpture machines—the artist employs them to divorce the act of creation from direct

fig. 1
SPECIMEN CASE, 1995
Polymer, mahogany, pins, and Plexiglas
48 x 60 x 5 inches
Private Collection

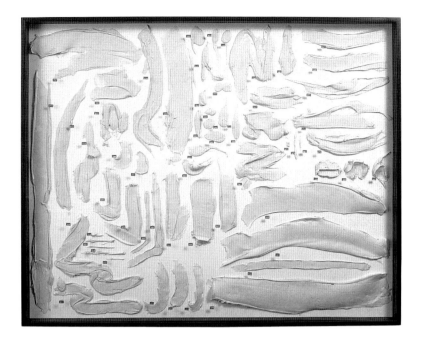

human gesture and touch, and casts doubt upon the value of the unique art object. By mechanizing the act of painting, Paine seems to echo philosopher Walter Benjamin's observation, "the instant the criterion of authenticity ceases to be applicable to artistic production, the total function of art is reversed."[7]

When Paine says that painting is "inherently absurd," he is referencing the empirical fact that art does not serve a biological function. Although this seemingly antiseptic, analytical attitude towards painting can be viewed as a harsh critique of the medium, Paine is not making a nihilistic statement about art, nor is he consumed with technology. His works are not sterile investigations into epistemology or ontology, but works of art that relate to the human struggle to understand an increasingly inhuman, technological world.

In fact, Paine's machines and their products consistently remind us that the hands of an artist created these. He designs the computer programs for his machines, and in *PMU* his presence is suggested by the empty chair before the laptop, as if the artist has taken a break, leaving his cigarette butts in the adjoining ashtray. More importantly, he animates *PMU* to produce works that resonate with the human touch. *PMU*'s canvases are aesthetically appealing, altogether unexpected from a machine. As Paine has said, "If the objects produced weren't compelling, the pieces would be failures."[8]

Simultaneously with the machines, Paine produced a series of faux botanical specimens as an investigation into our perceptions of the real and the artificial. Stimulated by his interest in botany, Paine creates facsimile "fields" of such compelling realism that they are virtually indistinguishable from natural ones. In *Crop* (1997–8, pp. 44–45), the artist and his assistant cultivated poppy plants, molded their forms, then painstakingly hand-painted each reproduced plant. As botanically precise replicas, Paine's simulacra of nature cause us to doubt the veracity of our vision. The artist is toying with our sensibility by using the tools of perception psychology to reverse the natural process of constructing

fig. 2
BAD LAWN (detail), 1998
Epoxy, PVC, steel, wood, PETG, lacquer, oil
paint, and earth
48 x 120 x 84 inches
Collection The Wanås Foundation,
Knislinge, Sweden

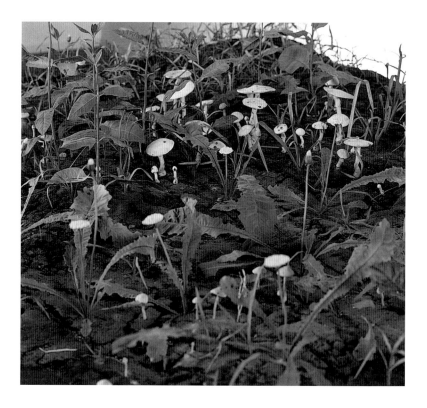

knowledge.[9] At the moment we recognize that an artist has created these convincing *trompe l'oeil* illusions of nature, Paine has succeeded in altering our expectations of the capabilities of the artist's hand.

Yet, Paine also contradicts the perceptual illusion. The artist encased his *Poison Ivy Field (Toxicodendron radicans)* (1997, pp. 42–43) in a scientific specimen box to remove it from any reference to a natural environment. *Crop* and the various mushroom series defy their naturalism by either "growing" on hard wood floors or climbing across the wall. Paine invests each of his works with romantic metaphors as well. His choice of poppy plants and mushrooms references the mind and perception altering possibilities of opiates, providing, in his words, "a visual equivalent of the hallucinogenic state."[10] In *Crop* Paine also introduced the traditional metaphor of the cycle of life, presenting the poppy in its various stages from germination and growth to decay. His more domestic botanical specimens allude to childhood experiences, ironically satirizing suburban, middle-class aspirations for a cultivated lawn in *Poison Ivy Field* and *Bad Lawn* (1998, figs. 2 and 20).

Recently, Paine has moved from botanical verisimilitude to take more artistic license in exploring the aesthetic possibilities of the natural environment. Instead of molding precise facsimiles, he now draws upon his considerable memory of fungi to improvise his own "natural" forms works such as his *Amanita Virosa* mushrooms series (pp. 56–57). Paine has also expanded his repertoire of organic subjects to include metabolizing organic matter as seen in *Dry Rot* (2001, fig. 8 and p. 53) and *Sulphur Shelf Wall* (2001, pp. 68–69). His exploration of the visually aesthetic qualities of the organic world reached its most extreme expression in the free-form improvisation artfully titled, *Abstract No. 6* (2000, p. 52).

Stylistically diverse, conceptually focused, Paine's art demonstrates remarkable breadth in its visual form, its metaphorical meaning, and its theoretical reach. The artist speaks to us in many different languages. He chooses the various forms for his art to give material expression to his questions about our perception and construction of knowledge. Drawing upon many disciplines, Paine contrives to reverse our presumptions through a series of illusions. In his study on *How the Mind Works*, Steven Pinker reveals that illusions "unmask the assumptions that natural selection installed to allow us to solve unsolvable problems and know…what is out there."[11] With his art-making machines and faux botanical specimens, Paine subverts our expectations of the act of creation: machines make art, and the artist makes nature. The artist is not motivated by a nihilistic desire to destroy our foundation of knowledge. Instead, he strives to make us aware of some of the changes that have come with our digital age.

Paine is a complex artist who embraces these inherent contradictions. Even as his machines distance the artist from the creative act, he confirms his role as maker, whether programming sensitive, mechanized works of art or exploring natural metaphors of the human condition. Playing with the ramifications of automatic human expression or inferring the potential for genetically engineered nature, the artist reminds us that these are some of the troubling issues of our era. Updating McLuhan's insights, Jean Baudrillard writes about the digital age, "It is no longer a question of imitation, nor duplication, nor even parody. It is a question of substituting the signs of the real for the real."[12] Paine is creating some of those signposts that mark new territory in mechanical, natural, and human creation.

11

JOSEPH D. KETNER

NOTES

1. In addition to gallery shows in New York, Los Angeles and Berlin, Paine's work was included in P.S.1's *Greater New York: New Art in New York Now* (2000), the San Francisco Museum of Modern Art's *010101: Art in Technological Times* (2001), and Give *and Take* at the Victoria and Albert Museum, London (2001).

2. See Jonathan Fineberg, "Roxy Paine's Non-Linear Engineering," in *Roxy Paine*, (Chicago: Terra Museum of American Art, 1998), 10.

3. Erik Bakke, "Roxy Paine Studio Visit," *NY Arts Magazine* (1999): www.nyartsmagazine.com/28/12.html. Paine and his critics repeatedly reference his altering the perception of the viewer through his art, particularly the faux botanical specimens. See also Fineberg, 26; Ann Landi, "The Big Dipper," *ARTnews*, v. 100, no. 1 (January 2001), 137; and Tan Lin, *Roxy Paine: Drug Technology and the Laborious Addiction of Work*, exh. brochure (Kansas City, MO: Grand Arts, 2001).

4. Marshall McLuhan, *Understanding Media: The Extensions of Man.* (1964; reprint, Cambridge and London: MIT Press, 1994), 75.

5. From Roxy Paine's Notebooks (April 17, 1997), quoted in Fineberg, 18.

6. Roxy Paine, quoted in Scott Rothkopf, "Semi-Automatic," in *Roxy Paine*, exh. cat. (New York: James Cohan Gallery, 2001), 25.

7. Walter Benjamin, "The Work of Art in the Age of Mechanical Reproduction," in *Illuminations* (New York: Schocken Books, 1988), 224.

8. Roxy Paine, quoted Rothkopf, 27.

9. Steven Pinker, *How the Mind Works* (New York and London: W.W. Norton & Co., 1997), 211–212.

10. Roxy Paine, quoted Fineberg, 26.

11. Pinker, 212.

12. Jean Baudrillard, *Simulacra and Simulation* (Ann Arbor: University of Michigan Press, 1994), 2.

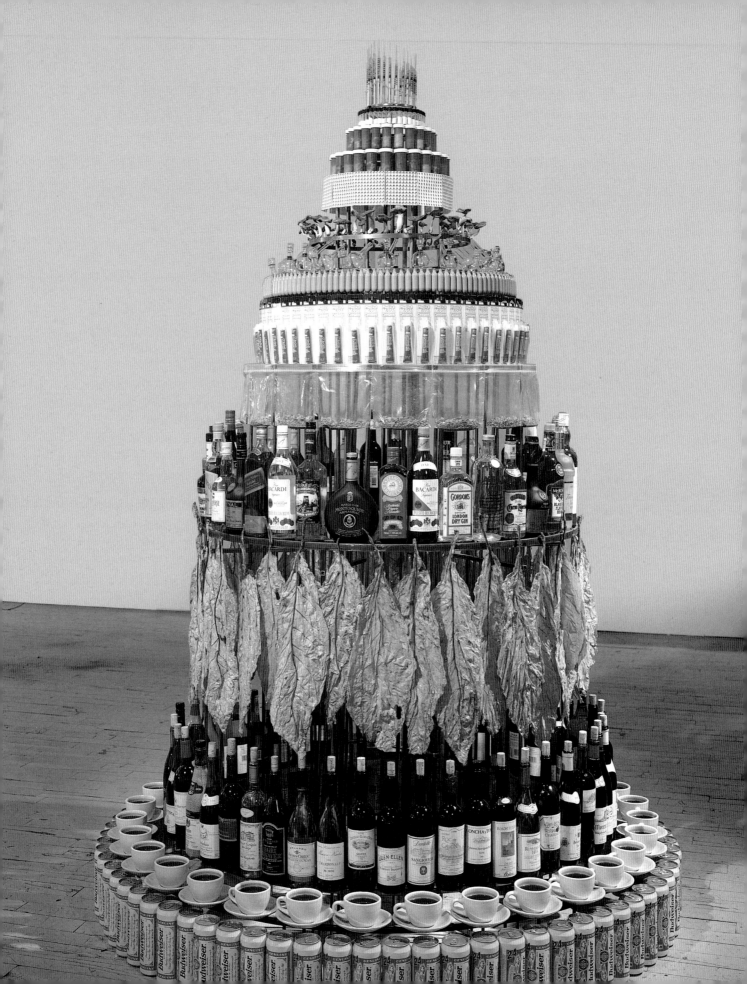

The following interview between Roxy Paine and Lynn M. Herbert took place on January 13, 2002, at Paine's studio in Brooklyn, New York.

LH: *Roxy, I'm interested in how certain aspects of your background may have contributed to the direction of your work. For instance, models and the concept of model making have an important place in your work. Were models a part of your childhood?*

RP: That's interesting. No, my brother was an obsessive model maker, a train set kind of kid, but I really wasn't. In retrospect, I think that rather than experiencing it, I was watching and longing for it, observing it. I think that that is what came out later with the model kits. More than my own direct experience, it was observation from a distance, and perhaps desire.

LH: *And your interest in nature?*

RP: Well, I grew up in suburbia, where there is such a twisted vision of nature. There's an overwhelming blandness in northern Virginia where I grew up. It's just strip malls, churches and perfect lawns. Inside the beltway is a vision of hell. I've talked to other people who grew up there and they feel similarly. I was aware of it when I moved from Holland where we had lived for a few years. I remember being incredibly aware of the difference.

There was a creek nearby when I was growing up. That's where I spent most of my time. I would constantly reroute the stream, building dams. I was mostly interested in the water. What I remember distinctly about nature in the suburbs were the borders. The natural world is totally controlled and manipulated in suburbia. Then there are border areas between housing developments; a small strip of land that is untamed and wild. The creek was that kind of area. And when I got to be thirteen or fourteen, those areas were the areas where I went to do the illicit activities, like exploring alcohol and drugs.

LH: *You also developed a love of hiking when you were young.*

RP: That was my brother's influence. He's a total outdoor western guy, big rock climber. When I was fifteen, I ran away to California and we spent some time together. He turned me onto places like Yosemite and Joshua Tree (pp. 1 and 38–39), and I really got a taste for hiking. He'd take me rock climbing, but I was more interested in being on terra firma. I still hike now. I go up to the Highlands near Cold Spring. You go straight up the Hudson River and it's great for short hikes, very immediate gratification. I love the Catskills, too. And if I had my way, I'd be out in Utah more.

LH: *Was there anything from your childhood in particular that you think contributed to your becoming an artist?*

RP: When I ran away and went to California, I decided then that I was going to be an artist. I didn't exactly know what that meant, but it seemed like the most interesting choice at the time.

LH: *What happened next?*

INTERVIEW WITH ROXY PAINE

Lynn M. Herbert

fig. 3
DRUG ZIGGURAT, 1993
Mixed media installation
94 x 72 x 72 inches
Courtesy the artist and James Cohan Gallery,
New York

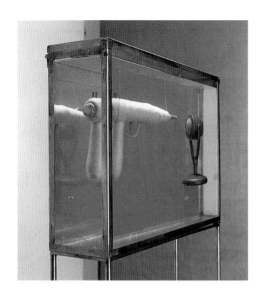

fig. 4
DERELICT (detail), 1992
Carrots and microphone in pickling solution
72 x 6 x 6 inches
Courtesy the artist (no longer exists)

RP: What came next… I moved to New Mexico and was taking classes at the College of Santa Fe—I'd gotten a GED. In general, the teachers hated me. I always had problems with art teachers. I don't know why. I didn't go in trying to be confrontational, but it always ended up with bad blood somehow. With all the bad blood, I became convinced that New York was the only way, the salvation.

So I went to Pratt for a time, but eventually dropped out. I started as a painting major, but then switched to sculpture. At first I was doing some fairly bad paintings. Then I started making musical instruments, horns made out of ceramic that were functional but also physically very beautiful. Strange drooping and twisting forms, sometimes with metal elements added. You could play them: I didn't have the proper trumpet techniques—I could only get a couple of notes out of them—but a real trumpet player could get a bunch of notes. And then, in early 1989, I started Brand Name Damages in Williamsburg with some people I had known from Pratt.

LH: *Was it an alternative space?*
RP: Yes, it was completely alternative *(laugh)*. It was great and completely chaotic. There were four of us who started it, but then it grew into a large collective, with twenty people running the place, which is insane, but also very educational. For me, it was a much better education than Pratt was providing. School was theory without practice, which is fine for a time, but it was much more informative for me to actually practice, to throw it out there and be able to fail in public and learn from that.

LH: *Can you describe some of your works from that period?*
RP: One piece was a gun made out of carrots. In another, a chair was on the wall with a metal diving board coming out of it with several vegetables balanced on the edge. Then there was a contraption that had three different brushes dipping into ketchup, white paint, and motor oil. The brushes were on springs and would come up and hit a bar and splatter these liquids on the window, so there was all kinds of crazy mixing of these materials on the window (*Viscous Pult*, fig. 5).

LH: *Aside from Brand Name Damages, what about the things that were going on in Williamsburg at that time. In retrospect, what did all of that mean to you as an artist?*
RP: When I look back at that time, one thing that was so amazing was that there was an incredible energy, but there was no money. The art market had completely deflated in the late 1980s so… I hate to say purity, but there was a pure energy of exploration about it that was really important to me. There were older artists and younger artists all thrown together—that was a beautiful part of it.

Technically, my first one-person show was at The Knitting Factory, and then I was in two-person shows at Brand Name Damages, but my first significant one-person show was at Herron Test-Site in Williamsburg. Annie Herron's place was the first big commercial try in Williamsburg, although it felt like an alternative space because there wasn't a whole lot of commercial activity going on *(laugh)*. There would be a thousand people at an opening—there was an intensity there.

For the show at Herron Test-Site, I remade the carrot-gun piece but inside

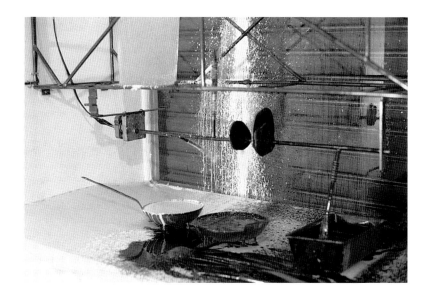

fig. 5
VISCOUS PULT, 1990
Steel, motor, latex, ketchup, acrylic paint, and
used motor oil
Approximately 52 x 38 x 23 inches
Courtesy the artist (no longer exists)

fig. 6
DISPLACED SINK, 1993
Sink, copper piping, soap, and water
Sink: 60 x 18 x 19½ inches
Soap: 61½ x 4 x 2½ inches
Courtesy the artist

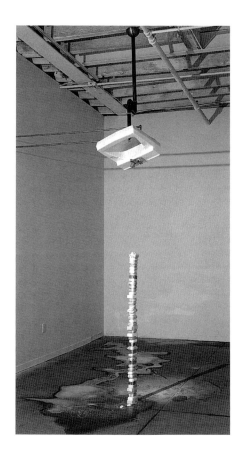

a tank of vinegar solution: Two carrots with metal parts for the trigger. It was pointing at a microphone inside the tank (*Derelict*, fig. 4).

LH: *What was that about?*

RP: I still don't know *(laugh)*. There was a puppet made out of vegetables—aluminum casts of different vegetables—a mechanized puppet that was doing a very awkward dance. There was *Lusts*—a piece that dunked a light bulb into a jar of oil and a separatory funnel into water (fig. 17). It is a floor-to-ceiling apparatus, so it really implements itself into the architecture. And there was a piece called *Kick Butt*—a boot that was kicking a cast of my own ass. The boot was lifted slowly up and it would come down and kick the ass repeatedly. There was a piece called *Displaced Sink* (fig. 6) that was a sink coming out of the ceiling. It was slowly dripping like a leaky faucet. It dripped onto a stack of soap bars that started out six feet tall but slowly eroded. Incredible soap scum puddles formed on the floor. There was definitely a play of the organic off of the very industrial. Automation versus the random or uncontrolled.

LH: *The works in the Herron Test-Site show seem to reflect the organic versus mechanical dialogue that has become such an important thread in your work. How conscious were you of it at the time?*

RP: I didn't have a strategy. I didn't have written out what I was attempting to accomplish. It was more like do it and keep doing it, throw it out there. Like anything, you become more aware of the themes running through it later.

LH: *What was the first piece in your botanical body of work?*

RP: The *Drug Ziggurat* (fig. 3) piece led into the botanical pieces. I did the *Drug Ziggurat* in 1993 at Exit Art in New York. Partly autobiographical, it's a sequence of 15 substances going up in strength that also follows the sequence that I took in experimentation [with them]. Beer is at the bottom, then coffee, then tobacco, then wine, through pot, nitrous, and the hallucinogens, with heroin

at the peak. And then I was going to do a mushroom piece on the floor, taking real mushrooms and putting them in jars and scattering them on the floor. The mushrooms began to rot and smelled horribly, so that led to making them out of another material. Then I removed the jars. That was the origin of what I call the "replicants." And I sort of divide them further into the fungus pieces, the weed pieces, and plant pieces.

LH: *A number of the early replicants are hallucinogenic plants.*
RP: Absolutely. That early piece with the mushrooms came out of the *Drug Ziggurat.*

LH: *Seen together, one realizes that by and large the hallucinogenic plants are (in the classic sense) less than beautiful, kind of the visual underdogs in the natural world.*
RP: That was interesting to me—that this stuff that comes from the shit, the base, can then inspire such a transformation or flight of mind.

LH: *Tell me about* Crop *(pp. 44–45).*
RP: That also grew out of reflection about personal experience and also thinking about the drug economy. I went through a heroin phase and really was screwed up for a period. Part of the piece is grappling with that. I wanted to have this perfect plot of land—as if it were cut from a field in Burma and displaced to New York. That was the impetus for having it look realistic. I realized that this was a serious time investment, but I wanted to take it as far as I possibly could. I looked at first for some way to find poppies that I could cast, but I couldn't find any poppies of the right species. But I discovered you can buy the seeds. So I bought seeds and grew them in Maine where they grew like banshees. They grew incredibly well, which was a bit surprising. Then I cast each part of the plant. The leaves—I cast twenty different leaves to get enough variation. Then I took the casts and manipulated them with heat or by cutting them differently. Twenty was a good number to get a great enough family of forms. Then I cast the pods in all different phases of growth (fig. 16).

LH: *How was it actually making the piece?*
RP: Actually, as I look back, it was one of those periods of my life that was hell. I was working feverishly on it and started getting into cocaine. And I was playing basketball and broke my foot—I was basically trapped in this studio as it was difficult to get around. So I was doing coke and making leaf after leaf after leaf. The level of detail on that piece is pretty insane. With the mushroom pieces, there is a large amount of detail, but with the poppies, it was that much detail cubed. I look back and wonder how I survived that. Coke is such a nasty drug. Even when it's good, it's not that good.

LH: *Is it important to you that so many of the replicants are of what most people would consider to be less visually appealing parts of nature—like the fungi and dry rot? You aren't afraid of ugly.*
RP: I think mushrooms are incredibly beautiful with all their variation of form. But, yes, I guess that was part of my initial attraction—that they were

fig. 7
MODEL FOR AN ABSTRACT SCULPTURE,
1997
Durham Rock Hard Water Putty, polymer,
steel, and auto paint
4 x 96 x 138 inches
Courtesy the artist and James Cohan Gallery,
New York

from a supposedly more base kingdom of nature. The idea that I was operating with, with the *Psilocybe cubensis Field* (fig. 19) and the opium poppy field, was this idea of potential—something existing in this state of potential. This idea also carries over into works like the *Model for Abstract Sculpture* and the *Model Painting* (fig. 7 and pp. 46). That was what I was operating with at that time: something that is waiting to have its ultimate effect or that's waiting to reach its final form. I saw this as a good analogy for art itself: something that's in this transitional state, which reaches its final form only in the mind.

LH: *With the* Amanita Virosa *works (pp. 56–57), there's the terrible irony that this beautiful, almost ethereal, white mushroom will in fact kill you if you ingest even a little bit of it. It is deadly poisonous. Does the idea of dangerous beauty enter into your thinking?*
RP: That's a component. But what's really important about these pieces to me is the complexity of ideas in each piece. It's not about one idea but many many ideas. That's appealing to me.

LH: *You've made large wall installations with the* Amanita Virosa *and you've also made more contained "paintings" with them.*
RP: First came the floor pieces, but the wall pieces are very much like the floor pieces. It's about different things as well, but it's more about being uncontained and being totally implemented into the architecture, playing off the architecture and playing off the space and the metaphorical richness of that terrain. Another component is about painting—the wall plane, the single plane of viewing—establishing this relationship of viewer and plane, and recognizing that there are different ways to experience it. The play of shape and form, color and light—that's yet another component of it. So I guess the contained works are taking that idea of painting more literally.

fig. 8
DRY ROT, 2001
Fiberglass, epoxy, lacquer and oil paint
68 x 90 x 8 inches
Collection Roger Conn and Ann Hoger

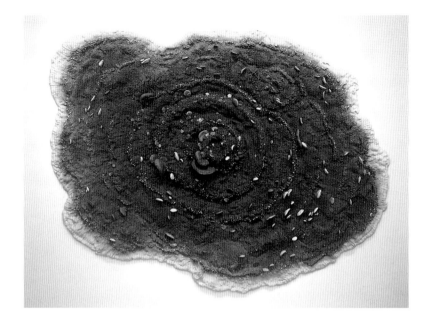

LH: *In* Poison Ivy Field (Toxicodendron radicans) *(pp. 42–43), you've added the dimension of humankind's detritus in the form of such items as a Thunderbird wine bottle and discarded condoms.*

RP: I think the *Poison Ivy Field* relates more directly to the suburbs where I grew up and this idea of a transitional zone. This undesired element—which is like poison ivy that you throw all kinds of chemicals on to keep it from growing. Society tries to thwart these in between areas where experimental activities are taking place. The work is a meditation on that.

LH: *Your plants never die.*

RP: Hmmm. Yes, that's the vanity of humans *(laugh)*.

LH: *Where does death come into the equation? In* Crop *you have the different phases of the poppy's life cycle.*

RP: But I'm not really seeking to show the different life stages of the poppy plant. It's a subrhythm or subplot within the main plot. That my plants don't die—I guess that's one of the contradictions I'm playing with, that I'm interested in. This permanence/impermanence idea, this idea of artificial and natural. I guess at best I want it to function as a meditation on these things. I'm not interested in creating any kind of didactic lesson.

LH: *The* Dry Rot *works and then the* Abstract *series look positively painterly when compared to some of the other works (fig. 8, pp. 52–53).*

RP: As I got into the fungus, I started looking at these crusts and immediately thought of paintings. This wonderful spreading quality, and thinking about paint as something that spreads and creeps and grows on a canvas, fouling it forever *(laugh)*. The first *Dry Rots* were inside specimen cases, so those were simultaneously existing as a specimen (and something that was destroying the

specimens, eating them away), and as a painting. I do see these pieces as transitional. Especially the *Abstracts*. They are clear transitions between the painting machines and the fungus pieces. The *Abstracts* are completely fictitious. There is no species like that.

LH: *And yet in the context of your work, we find ourselves looking at them and wanting to believe that they are some existing species.*
RP: Absolutely. I like those hazy areas.

LH: *Where does humor fit into the equation for you?*
RP: Humor is important. It's not a joke humor, but hopefully it's the humor that comes out of dealing with the complexities of nature and this world—the kind of humor that is essential to survive. But I don't want humor to become dominant. It's just one component of the work. My ideal would be that you would see a piece differently every day. One day you might see the humor, and one day it might seem deadly serious to you.

LH: *Can we talk a little about your growing forest of stainless steel trees?*
RP: Yes, my goal is to replace all trees with "new and improved" rot resistant trees *(laugh)*. No, for me they are about ideas of permanence and impermanence, artificiality and contradictions in nature. It's reducing this magnificent thing to a system of step-by-step instructions and the contradictions inherent in that idea. We haven't yet talked about the idea of systems in these pieces, the idea of creating a language. For me, some of the elements of that language are borrowed (trees being borrowed from nature). The language is made up of elements and rules, and then you can improvise freely and discover the infinite variation within that system—contradiction of limitations and definite constraints when what you're really dealing with is infinite possibility.

LH: *The trees aren't as realistic, if you will, as, say, the mushrooms and poppies. You seem to be headed in a slightly different direction with them.*
RP: It's more like taking something as far as possible rather than making something look as real as possible, which is an important distinction for me. Tomorrow I could make stainless steel mushrooms, but the core issue of the system and the language would still be there.

LH: *Why stainless steel?*
RP: Well, the idea of permanence. Stainless is what we think of as being permanent. Although it's also our human vanity to think that.

LH: *How do you decide what form the tree will take?*
RP: With the first one, the Swedish tree (*Imposter*, fig. 9), I was really winging it. I'd never done it before and I was trying to figure out how the hell to do it. We made all these branches first, and then I went about composing in space. Formal issues came into play: I was seeking to make a dynamic form and also playing off of the core of what a real tree is doing, the decisions that are being made by a tree at each juncture.

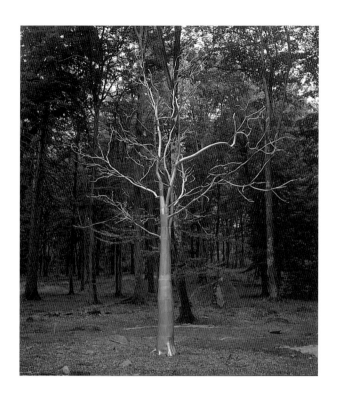

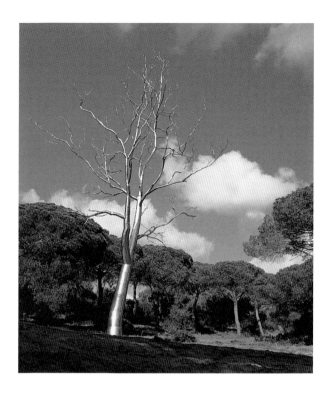

fig. 9
IMPOSTOR, 1999
Stainless steel and concrete
27 x 18 x 18 feet
Collection The Wanås Foundation,
Knislinge, Sweden

fig. 10
TRANSPLANT, 2001
Stainless steel and concrete
42 x 29 x 29 feet
Collection Montenmedio Arte
Contemporaneo, Cadiz, Spain

LH: *How do you go about siting these trees?*

RP: Actually, with Central Park, they presented it to us as if we had a choice, but in the end there was really only one place where it was possible to go. It wasn't my ideal situation, but then it's remarkable that they're allowing a piece to be placed in Central Park at all (*Bluff*, p. 71).

I like the works to play off the site. I like them to be in the forest but also in a clearing, so that you have both integration as well as separation. The Swedish tree is surrounded by towering elms and ashes, and the tree plays off of their forms; which is why it's titled *Impostor*. In Spain, the tree is called *Transplant* (fig. 10), and it's very much foreign to its environment and foreign to the other trees around it. It's very different. It's a tree that wouldn't grow in that dry semiarid southern climate. So, I like to play with the individual circumstances of each location.

LH: *How do you engineer these trees and is that process of particular interest to you?*

RP: Yes, right now I'm totally involved in it. I love that, although sometimes I hate it passionately *(laugh)*. It's hard to switch between modes sometimes. For me it's a very different mode from thinking and talking about the work. Engineering, problem solving, dealing with corrosion issues … it's a very technical language, and this is a very conceptual language, so sometimes I find it a bit schizophrenic going back and forth.

LH: *Are these a kind of "übertree" destined to live forever? In the midst of human-kind's rampant deforestation?*

RP: Hopefully they are multifunctional. I believe in multifunctional art. There might be some ideas of that in there, but it's not really my focus. Maybe

not "übertree" but some kind of distilling of growth, the idea of growth. Even though it's permanent, it's dead. It's a dead material, stainless steel.

LH: *The design of your art-making machines has a similar essential, no-frills look.*
RP: There's nothing added for aesthetics, nothing unnecessary, no filler material.

LH: *One of the wonderful ironies about your machines is how slowly they work. Our expectation of machines is that they will work very quickly, get the job done faster.*
RP: And it's as if mine are suspended in amber or thick honey. Yes, the process is very slow, but again it's essential. It's all tied into the drying times or the cooling times of the materials.

LH: *We also expect machines to make things that look manufactured, and your machines make works of art that look very organic.*
RP: In a way they're actually portraits of the materials that each machine works with. They get at the core essence of whatever the material is. Like the polyethylene that makes the *Scumaks*: the viscosity, the hardness, the molecular structure … that is what causes them to make these forms, so they really are in some ways material portraits (figs. 13–14, pp. 62–63, 66–67).

LH: *Speaking of hardness, you used to allow the* Scumaks *to simply fall off on the floor when they reached the end of the conveyor belt.*
RP: In the first show I did. Since then I haven't because they get scuffed when they fall, so I guess that's a nod to the commercial side of the piece. They're all numbered and signed, and I've kept up with that record better with the new *SCUMAK* machine (fig. 23, pp. 64–65).

LH: *In the commercial realm, your machine works raise interesting questions such as: If someone buys one of your machines, are they free to generate as many individual artworks as they want?*

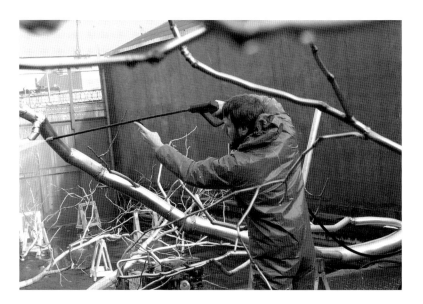

fig. 11
The artist working on BLUFF, January 2002,
Red Hook, Brooklyn, New York

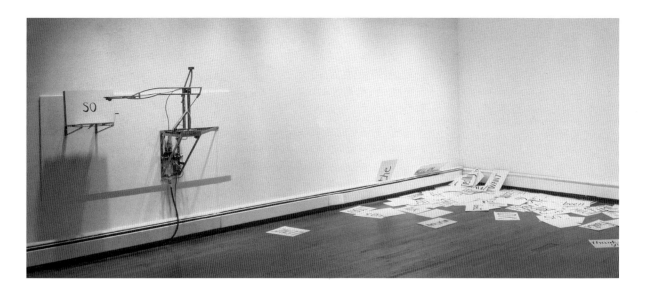

fig. 12
PLACARD FLINGER, 1995
Steel, pneumatics, and ink on cardboard
48 x 60 x 24 inches
Courtesy the artist and James Cohan Gallery,
New York

RP: If someone buys a machine, they are limited in the number of works they can produce. I can control that with the materials as they are distinct formulas. If the material was changed, you'd get a completely different object. I had to test quite a bit to find the right formula to do just what I wanted the material to be able to do. With the *[Paint] Dipper* (fig. 22), I tested thirty different paints before I found a formula that would work. It's not as complicated with the *Drawing Machine* (pp. 60–61), for that is simply ink, but with the other machines, they only work with very specific material formulations.

LH: *Is the performative aspect of these machines important to you?*
RP: There is some of that in them, but I prefer to think of them as doing their essential function: they're doing their job according to their own schedule determined by the materials, determined by the program, and if you come and see it in action, that's great, and if you come and the machine is in a cooling and drying phase, that's fine, too.

LH: *A number of critics have discussed your* PMU *paintings (pp. 2–3, 48–49) within the context of monochromes. Is that how you see them, and where does color fit into the system?*
RP: You can read that into them. But for me it's more about keeping the focus on the process. The thing that is most important to me is that they are a record of their own making. Color with the paintings just felt like more of a distraction. Of course, the *Scumaks* use color, but they are much more in the realm of plastics and referencing the history of plastic in the twentieth century. Color is often an essential feature of plastic.

LH: *It's interesting to think back to the earlier machines and their relationship to these more recent machines.*
RP: The *[Placard] Flinger* (fig. 12) is more related to these than say *Kick Butt* because in a way it's producing a sculpture on the floor. And *Viscous Pult* (fig. 5) was creating as well, but with ketchup, used motor oil, and white paint. That was hell to clean up.

LH: *So some of the machines have made art, and others …*

RP: … have just made a mess *(laugh).*

LH: *There's a relatively small but strong heritage of machine art in art history. One thinks of the works of Jean Tinguely, Marcel Duchamp, Robert Rauschenberg, Rebecca Horn, and more recently Tim Hawkinson.*

RP: Yeah, it's all interesting; it's all good stuff. We're all influenced by others, but I'm not that interested in keeping that lineage going. I'm not interested in their works, say, any more than I'm interested in paintings that I love. Yes, I feel connections, but I might feel more of a connection to a painter. It's more about the essential ideas I'm dealing with than the specific material or method.

LH: *Could you talk a bit about the "language" you use to instruct your machines to make an individual work and how it differs from machine to machine?*

RP: For me, there are in fact three distinct languages. First, there is the language of the overall operating program. We could call this the "meta program" or the autonomic nervous system. It keeps track of the motors, valves, heaters, etc. and sends instructions to them.

The second is the language of the object program; the program that is written anew for each object. This is the code or series of instructions that the meta program then carries out (fig. 14, p. 61). And the third language is the whole entity: how the meta program and the object program function along with the material, temperature, gravity, and time. In it you have the essential characteristics of language: a system of elements and rules or limitations that can generate an unlimited number of new forms.

As to how working with each machine differs, the language has developed from *Paint Dipper,* in which every single operation had to be written as a line of code, to *SCUMAK* which is much more graphic and intuitive. With *SCUMAK,* for instance, you have a series of levers that can be set anywhere between 0-20 minutes for the dispense time as well as the cooling time, so the number of possible programs is at least in the trillions. With the *PMU* (pp. 50–51) and the *Drawing Machine* (pp. 60–61), each layer is actually drawn on the computer, and I build each work layer upon layer. Then I work with the variables specific to the machines, such as drying time of the paint (between layers) or say the transparency of the ink.

LH: *How does that way of working, composing on a computer, relate or not relate to, say, making the replicants. Can you visualize what the end product is going to look like?*

RP: They are related conceptually, in that both ways begin with establishing a language and then inventing new forms within the constrains of that language. Having said that I can also appreciate the difference between the ways of working. And if I hit a brick wall with one I can switch to the other way for a time.

As to visualizing the end product, there is a relationship between the program and the object, but the relationship is sometimes elusive. In the *SCUMAK* for instance, you have the complex relationship between thermal dynamics, liquid dynamics, gravity and time. If my mind was able to compute these complexities better, I would be able to visualize more clearly the end result.

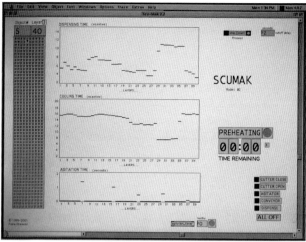

fig. 13
Scumak S2-P2-R5, 2001,
Polyethylene
19 x 18 x 12 inches
Courtesy the artist and James Cohan Gallery,
New York

fig. 14
Computer screenshot of program for
Scumak S2-P2-R5, 2001
Courtesy the artist

It is also very interesting when two *Scumaks* are made with the exact same program. You can see them as kind of fraternal twins, sharing a family relationship, but each having unique features.

LH: *Your work makes us question the nature of creation: natural versus manmade, organic versus mechanical. What do you think of Mother Nature as an artist?*
RP: I'm very influenced by southern Utah and the incredible forms at Zion National Park (fig. 15). I go there in awe and feel small and insignificant. I'm fascinated with natural processes. There you really see those processes exposed, and you see that recording of history in a very clear way that has been very influential to me. On the East Coast, everything is so covered with sediment and vegetation that you don't see the processes of time so clearly and I think that clarity is something I really sought in the *Dipper* and the machine process pieces.

LH: *Landscape has a way of appearing in your machine-made paintings, albeit in an abstract way.*
RP: Right, and even more than evoking specific landscape features, there's something about the process of how landscapes are formed.

LH: *Your "computer/machine generated" art leaves no perceptible trace of having been made by a computer/machine.*
RP: Yes, and the replicants also leave no trace of the human hand. These are some of the contradictions I am interested in exploring. It also has to do with digging up the assumptions and conventions in our minds and possibly revealing some new dirt.

LH: *Systems and control seem to be an underlying theme in your work. You seem to break them down or deconstruct them for us.*
RP: Yes, systems as a sort of paradigm of the more rational and logical side. I've become more interested in them, having worked on the machines and one species of mushroom so long. I see that that is a thread that goes through much of the work even when I was less conscious of it.

LH: *There also seems to be an ongoing dialogue between control and chaos.*

RP: I tend not to use the word chaos, I think of it more as situations too complex to predict. It stems, I think from being a control freak, but understanding that control without its opposite is uninteresting.

LH: *There's also a wonderfully obsessive quality running through your work. Even early on, the nine months of research that you did, say, for the* Dinner of the Dictators *(fig. 18), trying to discover each of the twelve dictators' eating habits.*

RP: I like a challenge. I like a challenge that takes me out of myself a bit, although that also leads to moments of extreme frustration. There were moments with the *Dinner* piece that I thought I'd never make it to twelve dictators. I had an "A" list of dictators and a "B" list. I think I got eight of my "A" list. For instance, Pinochet was on my "A" list, but everyone I talked to who might have had any knowledge was very scared when I called. "Why do you want to know?" They thought I was going to try to poison him or something. Living dictators were more difficult, except ones like Suharto (who was alive at the time). There the element of vanity helped—the Indonesian Embassy sent me a brochure about him and his life, so that was one of the easier ones to get.

LH: *Envisioning the works in this exhibition all together, there is an element of the spectacular, but also a surprising element of humility.*

RP: To begin with, the titles are usually humble. They're not trying to dictate too much—they leave more up to the viewer. And with the works, I'm conscious of wanting to present it, put it out there, without a fanfare.

LH: *And irony? Your work presents us with so many contradictions.*

RP: Didn't irony die recently? *(laugh)* Yes, irony is a component, but I refuse to make cynical works. The irony that enters my works comes from dealing with the inherent complexity of things. Sometimes the best way to mean one thing is to say another.

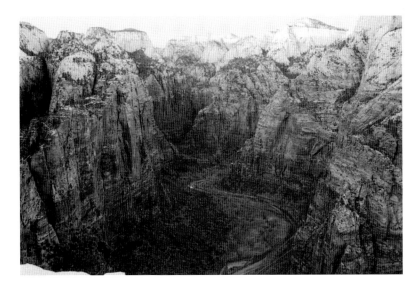

fig. 15
Zion National Park in southwestern Utah,
photograph by Roxy Paine.

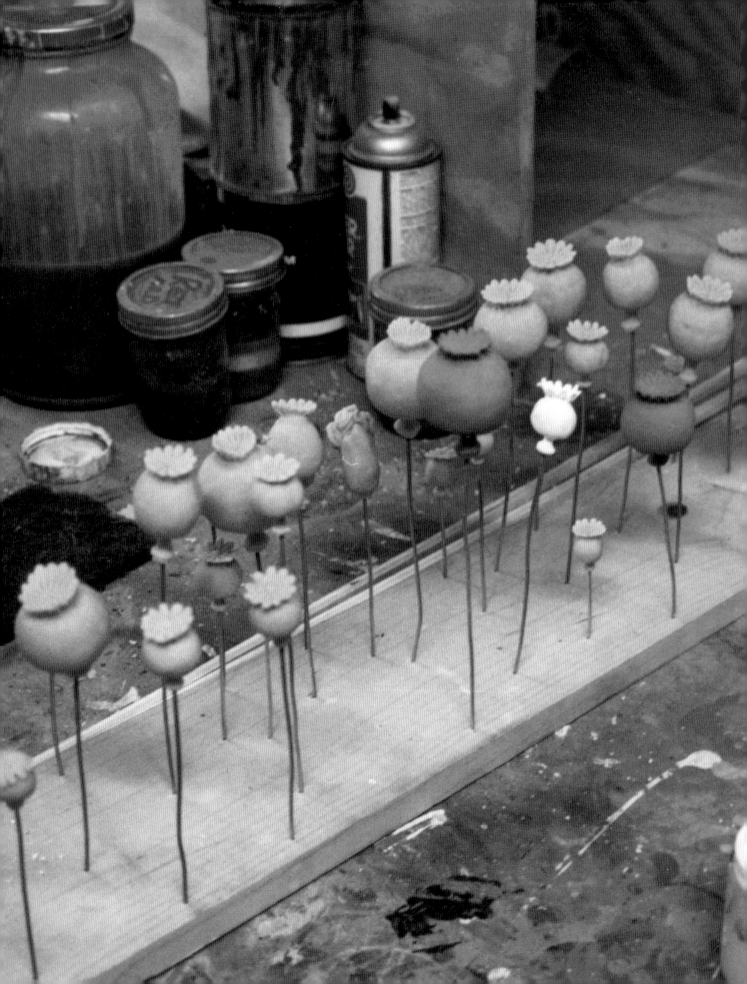

1 I recall reading some of Donald Judd's criticism and reviews from the early 1960s, including a fascinating short review of a group show featuring several of Eva Hesse's paintings. Judd examined the paintings, paying particular attention, as was his wont, to really precise formal and factual things like coloration, shape, and texture. Then with a remarkable prescience, he concluded by stating, in effect, that while the paintings were of interest, it was more interesting to imagine what this artist might be up to in, say, five years. In five years or so, of course, Eva Hesse, at the time of Judd's review still a beginning painter extricating herself from Yale and Josef Albers, would become, well, *Eva Hesse*, deep into a remarkable if sadly abbreviated career filled with quasi-organic sculptures made out of such synthetic stuff as fiberglass, polyethylene, and latex. Her work paved the way for Roxy Paine's own adventures in synthetic natural forms, but also for many other sculptors, especially those coupling nature and synthetic materials with a great deal of psychological voyaging and poetic resonance.

I mention this now, however, not because of the implicit links between Hesse and Paine, but because I wish that I had had such critical prescience when Paine first began showing his work in 1990 and 1991 at the artist-run collective Brand Name Damages in Williamsburg, Brooklyn, and in 1992 at the short-lived but ambitious Herron Test-Site, also in Williamsburg. At the time (and it was quite a time in Williamsburg, when the developing alternative arts scene was vivid and flourishing, and when much of what transpired seemed generous, inquisitive, unburdened by posturing and hierarchies, and altogether exhilarating), Paine's work was adept and intriguing, but not excessively so, and it didn't suggest the truly radical and eccentric projects that would come a few years later. At Brand Name Damages, Paine rigged up a rudimentary kinetic device that featured a paint brush smearing the gallery's front window with white paint, ketchup, and motor oil in a kind of hysterical and obsessive painting action (*Viscous Pult*, 1990, fig. 5). With perfect hindsight, we can see that this work anticipated the extraordinary painting, sculpture, and drawing machines of the past several years, but back then it seemed much more like a gleeful and ironic raid on good taste and the iconic, high art/big money status of circa 1980s painting. At Herron Test-Site, where Paine had a one person show in October 1992, a work called *Lusts* (1992, fig. 17) featured a metal apparatus with two moving arms that periodically plunged two light bulbs into glass bowls on the floor, one filled with motor oil, and the other with water. Fragility mixed with force in this work, which was repetitive, obsessive, humorous, and suffused with a sublimated sexual charge. I also recall a so-called "carrot gun," in which a raw carrot morphed into a revolver (*Derelict*, 1992, fig. 4); a sculpture in which a mechanized boot repeatedly kicked a cast of the artist's own ass; and a leaking pipe, protruding at an angle from the ceiling, which dripped water onto a vertical stack of soap bars, spreading an oily film of soap scum on the floor (*Displaced Sink*, 1992, fig. 6).

These quasi-scientific works were smart and adventurous, and they mixed a sort of bad boy rebelliousness with a brooding intensity and doses of offbeat

ROXY PAINE: DREAMS AND MATHEMATICS

Gregory Volk

fig. 16
CROP in progress, the artist's studio,
Brooklyn, New York, 1997

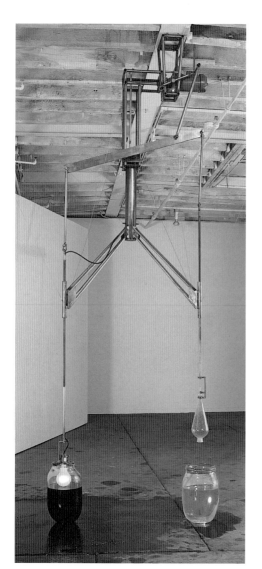

fig. 17
LUSTS, 1992
Glass, water, steel, light bulb, and motor oil
120 x 84 x 30 inches
Courtesy the artist and James Cohan Gallery,
New York

humor, for instance soap that made a mess out of things, and a carrot that was really, really bad for you. They also suggested the kind of poetics—and by "poetics" I mean an ability to suggest multiple meanings simultaneously, compressed into a single image, object, or event—for which Paine has subsequently become known. Still, the work, while compelling, didn't offer any startling breakthroughs. That would come later.

It would come, in fact, with Paine's next one-person exhibition, this time at the Ronald Feldman Gallery in SoHo in 1995, specifically with a work displayed near the back of the gallery's first room. Called *Dinner of the Dictators* (1993–95, fig. 18), it was probably the first time that all of Paine's developing concerns came together in a work that was as conceptually rigorous as it was visually lively. Encompassing his interest in categorization and display, in *trompe l'oeil*, in questions of input and output, in museum dioramas, in nature-culture collisions, and probably in quite a number of others as well, this work consisted of twelve dinner plates arrayed with the favorite food of twelve notorious dictators, all presented in an enclosed vitrine. The food for each dictator had been cooked, and then taken to a taxidermist where it was freeze-dried and preserved. On view were freeze-dried versions of Nicaraguan strongman Anastasio Samoza's frog's legs and a gin and tonic; Mao's fatty pork; Napoleon's chicken Provençal; Mussolini's tagliatelle and bowl of "unusually cut" vegetables; Hitler's yogurt, zwieback, mushrooms, honey, and pills made from the feces of healthy Bulgarian peasants; and Genghis Khan's partridges and horse blood, among others. At once wondrous and creepy, this was a table set for a dinner party from hell, a kind of freak show or rogues' gallery across the centuries. Call it a kind of Lenin in reverse: instead of a dictator's body (or dictators' bodies) preserved for all time, what was preserved here was the food that went into those bodies, that energized those peculiar psyches, and that ultimately resulted in world-shaking mayhem. Time, chemical processes, and an inevitability so basic as the spoilage of food seemed to be frozen in an endless, contemplative "now." But it was an especially conflicted "now," implying violence and evil, but also wonderment, and the weird idiosyncrasies of each individual (I wasn't aware, for instance, that Genghis Khan liked to drink the blood of a horse or that Hitler took pills made from feces as a quack remedy for his very understandable intestinal problems). That mere food, although technologically manipulated food, could be the vehicle for all of this was alarming. One was also amazed at the exacting and in many ways manic verve of the whole piece. As Paine has noted, the research alone took eight months, while the work's fastidious execution stretched across more than two years. While this was the first time, it certainly would not be the last that Paine has gone to extreme, even mind-numbing lengths to realize a piece.

In singling out this work, I don't mean to dismiss the other works in the show, which were also significant and which also pointed to the various manners in which Paine would subsequently proceed. A kinetic device on the wall (*Placard Flinger*, 1995, fig. 12) periodically tossed placards out on the floor; each placard featured a single word culled from Paine's sessions with his therapist at the time. If therapy is an effort to understand and presumably get control of one's unruly psyche, this machine did the opposite. It randomly tossed words

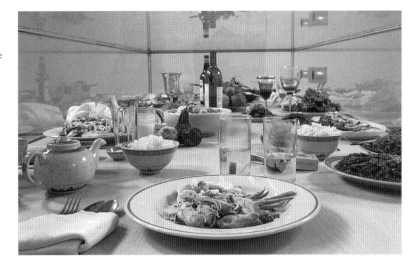

fig. 18
DINNER OF THE DICTATORS (detail),
1993–95
Freeze-dried food and place settings in glass case
47¼ x 118½ x 50 inches
Collection New School for Social Research,
New York

into a haphazard pile, making an illegible mess of those hard-won therapeutic discoveries. Here was another variation on, or a step towards, the art-producing machines that would commence in 1997 with Paine's first paint-dipping device; it's also one of numerous times when Paine has seeded his work with direct personal references. Nearby, *Big Head Cheese* (1995) involved an artificial version of head cheese made from bondo and clear resin. Still, *Dinner of the Dictators* was the show stopper, and for Paine it represented a substantial upping of the ante, an obsessiveness pursued for a long time, a work pushed to the extreme. The viewer, especially those viewers who had been following Paine's work for a few years, couldn't help but wonder, with a real curiosity, what might be coming next.

2 Since the 1995 exhibition, Paine has pursued two different routes in his work, that at first glance seem wildly diverse, but that actually connect on many levels: his synthetic replicas of botanical forms like fungi, poppies, grasses, weeds, and trees, and his intricate, computer-driven machines designed to auto-produce some very impressive artworks indeed. Paine's botanical forms take growing things occurring in nature and transform them into artificial replicas or mutants, painstakingly rendered from an assortment of polymer, fiberglass, lacquer, oil, stainless steel, and what have you. The results are so lifelike and hyper-detailed that an unsuspecting person could easily be hoodwinked, as many people have been. However, their realism is also deceptive. Things don't grow like this in nature, nor do they look like this exactly, for while sticking close to the original, Paine always includes his own designs, allowing a considerable leeway for his own riffs and inventions. What happens is an interpretation of the real or, better yet, a hallucination of the real, in which a magical, logic-defying quality emerges from what might otherwise seem known and familiar. A utopian element lurks beneath, a desire to remake the world, to make it better, to make it new and improved.

The machines, on the other hand, consist entirely of industrial and synthetic materials. Slowly through their lengthy, whirring, preprogrammed processes,

they produce equally synthetic "products"—acrylic paintings, for example, or sculptures made out of polyethylene. While primarily abstract, these ultra-artificial artworks somewhat surprisingly evoke all sorts of nature references, from layered rock formations in southern Utah (fig. 13, where Paine has frequently ventured), to dangling stalactites, from distant horizons and mountainous shapes, to various forms of topography. Moreover, the actual forces used—like heating and cooling, concentration and dispersal—are also primal landscape-shaping forces, in effect turning Paine's apparatuses into microcosms of vast world processes. Though made in the factory, so to speak, or on the assembly line, Paine's auto-produced objects yield a dialogue with the world out there on a large scale, and they've also got a sneaky air of sublime beauty, which is strange, especially when one realizes how they are actually made. I mean, if you wanted to make contemporary landscapes or landscape-derived paintings, sculptures, or drawings that retain an air of vastness, wildness, beauty, and sublimity, it's tough to imagine a more difficult, more time-consuming, more outrageous procedure than the one Paine has settled on.

Where both bodies of work really meet is a hybrid arena in which technology and nature intersect, whether it's Paine's use of computer programs for his machines, or his use of chemicals and metals for his plants. In Paine's work, representations of nature, however transformed and artificial, nevertheless retain a mind-bending, ecstatically tinged power, offering a decidedly idiosyncratic take on a utopian tradition in American art and literature that has long been based on ecstatic encounters with nature. This includes Emersonian Transcendentalism and Walt Whitman's poetry, as well as Hudson River School Romanticism and the shimmering, spiritualized landscapes and seascapes of the nineteenth century Luminists. More recently, one could point to elements of Land Art, James Turrell's sky installations in which an excised section of ceiling reveals the real sky, Agnes Martin's abstract desertscapes, and several of Edward Hopper's paintings in which ethereal, seemingly otherworldly shafts of sunlight illuminate otherwise bland domestic scenes, among many other examples. For Ralph Waldo Emerson, who influenced most immediately the Hudson River School painters and the Luminists, but also artists coming much later, the heart of the matter was an immersion in nature, and an art based on that immersion: a fluid, border-defying exchange between self and world. Paine courts a similar immersion, and a similar fluid exchange, yet now no longer with a "pure" nature (whatever that is), but instead with a socially molded nature, a nature infiltrated and infected by technology, consumerism, entertainment value, and various other controlling mechanisms.

Speaking of ecstatic encounters with nature, drugs figure prominently in several of Paine's botanical works, notably *Psilocybe cubensis Field* (1997, fig. 19), in which 2,200 fabricated hallucinogenic mushrooms are arrayed across the floor, where they "grow" without benefit of soil. In this case (and Paine has admitted as much), the work has a distinctly personal source. Born in 1966 in New York, Paine grew up in McLean, Virginia—*that* McLean, Virginia, home to *that* famously secretive institution. For a restless youngster growing up in, and feeling trapped by, a particularly concentrated version of 1970s suburbia, drugs were a readily available route to an alternative consciousness which, most

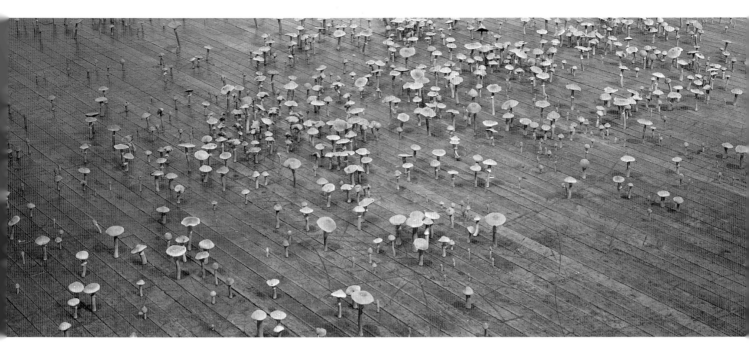

fig. 19
PSILOCYBE CUBENSIS FIELD, 1997
Polymer, lacquer and oil paint
4¼ x 328 x 222 inches
Collection Israel Museum, Jerusalem

assuredly, was not the mall, not the family and the local church, not the dinner hour, not the television, not politics as usual, not good grades, college, and a job. Many of these drug-taking excursions occurred not in the great outdoors, because there wasn't a great outdoors to speak of in McLean, or in the thousands of places like McLean in the U.S., but in slices of nature between or adjacent to various housing or commercial developments—a circumscribed nature that retained paltry yet palpable traces of a residual wildness. And so Paine, and a few million other disaffected, post-1960s teenagers, hightailed it to those thin creeks, to the vaguely dirty woods, to the local cliffs, to the fields with their sparse vegetation and inevitable litter, to chemically hotwire themselves into a kind of transcendence, or forgetting, or mixture of both, but mostly into a souped-up consciousness that had its pluses and its minuses. Drugs were a potentially transcendent, consciousness-changing vehicle, but they were also an escapist, addictive, potentially dangerous force, I mean for those who were just not saying no, and how one negotiated one's way between those two poles had a crucial impact on one's future.

In any event, Roxy Paine most certainly had such experiences, namely drug-assisted flights in what passed for nature in McLean, and it's interesting to note that both—drugs and circumscribed sections of the outdoors—would later appear with such effect in his work. These experiences increased when, at the age of 15, Paine left home to voyage through the American West, notably California, also spending several seasons "on tour" with the Grateful Dead— another questing, ecstatic milieu not known for its sobriety. There were, one imagines, adventures, and some of the adventures were of the consciousness-catapulting kind, including the use of hallucinogenic mushrooms.

With *Psilocybe cubensis Field*, Paine fashioned 2,000 plus of these mushrooms out of polymer and painted them by hand. It's possible to see this as a

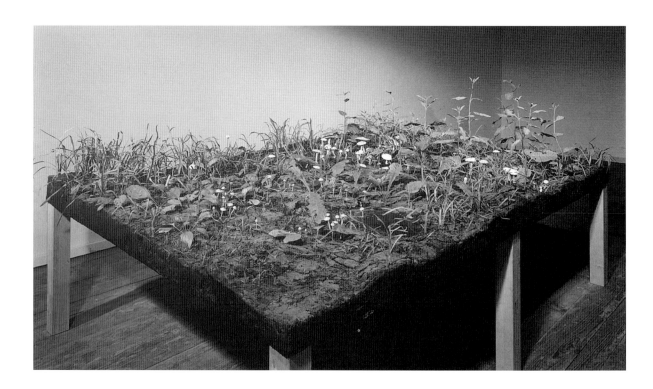

fig. 20
BAD LAWN (detail), 1998
Epoxy, PVC, steel, wood, PETG, lacquer, oil
paint, and earth
48 x 120 x 84 inches
Collection The Wanås Foundation,
Knislinge, Sweden

gigantic form of sublimation: instead of taking drugs, Paine made them. That's
one origin of the work, but like so many of Paine's pieces in this vein, things
immediately start getting a lot more complex . Clearly, these ersatz mushrooms
are also unnerving reminders of just how manipulable, hybrid, and artificial
nature has become in our times. They look like natural things, but they're all
slightly different, and they're all entirely composed of industrial strength poly-
mer, which makes them seem like science fiction freaks or some bioengineering
lab experiment gone terribly amok. Still, the work is oddly beautiful and sub-
lime, with its ripples and striations, textures and swirls. It floods an interior site
not with the fact of, but with the potential for, a radical alteration of con-
sciousness, yet now it's no longer the psychoactive "natural" drugs that do this,
but the artwork itself. Of course, there's also a built-in contradiction with these
mushrooms. In nature, they grow on waste and debris; they're digestors of excre-
ment. But if you digest them, they send your mind to stratospheric heights.

Paine's next major drug-based work is called *Crop* (1997–98, pp. 44–45),
and here the methodology is quite different. Rather than meticulously fabri-
cating an almost ridiculously complex field of mushrooms, he concentrated on
a small bed of poppies, first growing the flowers on a friend's property, and then
repeatedly casting them at all the different stages of the growth cycle. Using
these casts, he slowly built up the work with his synthetic materials, which he
then painted. The resulting truncated "garden," springing from a smallish bed
of soil (itself entirely fake), includes new buds, red flowers, fat buds oozing
white juice, and withered plants heading into mulch. Growth and decay share
close quarters, as do life and death, beauty and desolation. What's also apparent
is a furious tessellation of shifting viewpoints and human uses of these plants:
the red flowers signify springtime, romance, and whimsy, while the oozing,

vaguely menacing white juice reminds one of cravings, syringes, and overdoses. Under the guise of a convincing diorama lies another mind-bending hallucination, another endless "now," the alpha and omega of these plants, a moment outside of time when one rises above limitations and piecemeal vision to see the whole as a continuum—a desire shared by various religious seekers, Transcendentalists, artistic visionaries, and tripsters, among others. That Paine reached this kind of "ecstatic," all-seeing condition through dogged work, research, investigation, measurement, and painstaking fabrication only adds to the measure of the piece. Here's how Emerson encapsulated such an approach, with its mix of the visionary and the empirical: "We want the Exact and the Vast; we want our Dreams, and our Mathematics." This sounds very close to Paine's own methodology, in which an inquisitive, research-oriented rationalism gets mixed with startling imaginative flights. In the meantime, Paine's cropped "crop" on its small plot of fake dirt, his portable, drug-addled Eden, also reminds one of nothing so much as a garden plot in the suburbs or, even worse, a planter filled with nice geraniums. Throughout Paine's work, wildness and a kind of liberating, if unsteadying power abut what one could call the suburbanization or domestication of nature, which has everything to do with limiting such powers.

Even though he has occasionally referred to drugs in his work, most of Paine's nature simulacra don't include psychoactive materials at all, but instead focus on fungi, dry rot, grasses, weeds, and, more recently, denuded trees. He favors, in other words, things in nature that don't normally fit into our categories of the "good" and the "beautiful," even things like dry rot and poisonous mushrooms that are positively offputting. With *Bad Lawn* (1998, figs. 2 and 20), Paine returned to McLean, so to speak, and to the suburban sense that a good lawn is a pleasingly uniform one, free (usually via toxic herbicides) of unbeautiful, wild card growths like weeds, mushrooms, and poison ivy, and devoid of any nasty bare spots. Paine upended this equation, using synthetic materials to compose a section of lawn atop a table that consists of nothing but these "bad" examples of nature—nothing but weeds, blight, bare patches, fungi, and so forth. It's a hilarious piece, and also a deeply effective one, questioning the ideologies we impose on nature, and exploring how we fear nature's unruly elements and try to control them, even in our own front yards. With *New Fungus Crop* (1999, fig. 21), another tabletop piece, an intricate collection of mushrooms, big and small, makes you feel that you're looking at minute wonders of nature, or more precisely at the wonders of nature on some other planet (every fungus is different, and all were entirely invented by Paine). Either that, or some out-of-control genetic mutations virulently spreading like a disease.

During his sojourn West, Paine decided to be an artist, although, as he admits, he didn't have too many clear ideas about what this meant. Eventually he attended two art schools, intending to study painting, but he dropped out of both, concluding that the respective painting departments and perhaps painting altogether were exhausted or, as he once put it, "absurd." Interestingly, however, there are many signs that Paine very much remains a painter, just an extremely unorthodox one, and this includes his painting machines, but also the way he hand-paints his many botanical works. Increasingly, Paine's botanical

fig. 21
NEW FUNGUS CROP (detail), 1999
Epoxy, thermoset polymer, aluminum, stainless steel, wood, PETG, lacquer, oil paint, and earth
34 x 108 x 84 inches
Collection Hirshhorn Museum and Sculpture Garden, Smithsonian Institution, Washington, D.C., Joseph H. Hirshhorn Purchase Fund, 2001

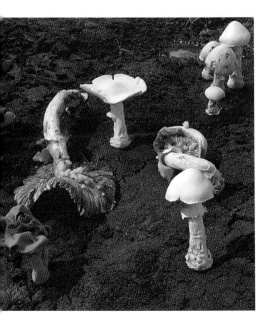

works themselves have taken on more explicit attributes of paintings, when presented either clinging to a canvas or directly on the wall. *Abstract #6* (2000, p. 52) is such a work, an intricate, three-dimensional tondo that synthetically replicates crust fungus. It's a close look at this material (a super-magnified look actually), but it's also a convincing abstract painting that suggests cosmic explosions, whirling nebulae, and interstellar debris as much as it does biological structures. *Amanita Virosa* (2001, pp. 56–57) is based on a luminously white mushroom that normally grows on the sides of oak trees, especially in Nova Scotia. One of the most beautiful of mushrooms, it's also one of the most deadly: eating just a small amount of it almost always results in a particularly gruesome death a few days later. In Paine's work, artificial (yet still beautiful) versions of this mushroom are fastened directly to the wall. Together, they make a wall installation, which is also a kind of painting sans canvas. Here the extreme danger of these mushrooms—for which there is no antidote—is held in abeyance. Everything is dire potential, but everything is also seductive and enthralling. Once again, big news of the outside, in this case mortal news, enters the space, and bequeaths a nerve-rattling intensity, that plays off the work's otherwise gorgeous serenity.

3 Roxy Paine's full-scale art-producing machines commenced in 1996 with his *Paint Dipper* (fig. 22), and to date have included his *PMU (Painting Manufacture Unit)* (pp. 50–51), two versions of sculpture-producing machines called *SCUMAKS* (fig. 23, pp. 64–65), and a drawing machine (pp. 60–61). *Paint Dipper* is an upright metal apparatus, controlled by a computer program, that periodically dips a canvas into a trough filled with white acrylic paint, then raises it to let it drip and eventually to dry in a process repeated over and over. The computerized variables are how long the painting is dipped, how often, and how much drying time is allowed. The finished paintings consist of multiple layers of paint with the hardened drips at the bottom. On one level, these paintings retain an unusual, machine-made look, as if they are wearing a jacket of paint or some other kind of wrapping that can be removed. On another level, their horizontal striations and stubby, dangling stalactites introduce an organic physicality, suggesting the sedimentary development of rock formations. As such, Paine's auto-produced paintings, which themselves take quite a long time to complete, subtly refer to the greater framework of geologic time and structures. Numerous critics have noted an ingrained or behind the scenes romanticism in Paine's work, which I think is exactly right. It is evident here in how automatic and in some ways ironic paintings suddenly seem to be implicated in time stretching across eons.

Of course, these paintings are also a send-up of the what-you-see-is-what-you-see school of Minimalist or Objective painting, especially monochromes. Paine oftentimes uses his eccentric methods to undermine whole genres. His *PMU*, first shown in 2001 at the James Cohan Gallery in New York, is a humorous raid on the whole mythology of Abstract Expressionist painting as an "event"(to use Harold Rosenberg's term) in which the brush is the vehicle for the artist's comprehensive "encounter" with the canvas. With

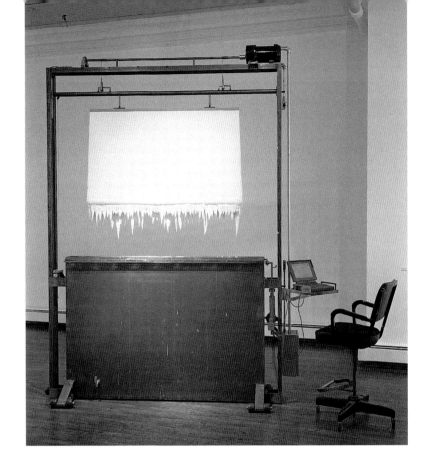

fig. 22
PAINT DIPPER, 1996
Steel, computer, interface, relays, acrylic paint, and chair
124 x 99 x 24 inches
Courtesy the artist and James Cohan Gallery, New York

Paine's work, every element of this encounter is mechanized, and reveals nothing of the artist's subjectivity, character, or charisma. A red light goes on, reminiscent of a warning light at a nuclear facility, and a siren goes off. A nozzle attached to a hose, which is attached to a pipe, which is attached to a vat full of paint, swings into motion. It finds its proper place in front of a canvas according to the computerized instructions, and then lets loose with three simultaneous jets of white paint, which strike the canvas. Some paint sticks, while the excess paint courses down to be collected in a trough and recycled for the next application (with all of Paine's machines, every part is functional and every part is necessary). The whole thing is absurd, and the whole thing makes perfect sense. It is a captivating mechanical performance filled with waiting, patience, brief moments of activity, and then more waiting, patience, and boredom. Then there are the results, and the results are compelling, coupling a hard-edged materialism with suggestions of horizons, cloud play, mists, and desert geology (pp. 1, 38–39). You are prepared to despise these paintings forthwith as latter day knock-offs of post-Duchamp readymades, until you realize that they're wonderful, mixing a full-tilt reappraisal of what a painting is exactly with a complex visual appeal and psychologically transportive beauty.

Encountering Paine's machines in a gallery or museum is a peculiar experience. They call to mind robotics, industrial engineering, and the drudgery of assembly lines—just about anything but the traditional hands-on activity of painting or sculpture. They seem to represent an end game for painting or sculpture, even a kind of post-artist art. But that's where the contradictions and surprises kick in. As sculptures themselves, or rather as sculptures-as-

fig. 23
SCUMAK (Auto Sculpture Maker) (detail),
1998
Aluminum, computer, conveyor, electronics,
extruder, stainless steel, polyethylene, and Teflon
96 x 168 x 48 inches
Private Collection, London

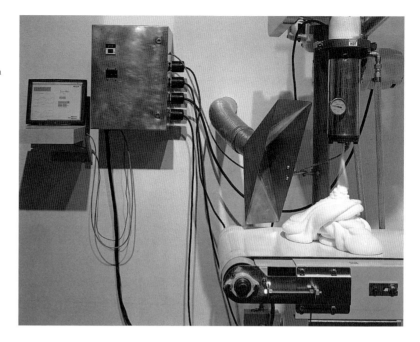

machines, they have a spare but elaborate beauty. You would think that these auto-producing machines would generate identical copies, but instead they produce complete originals—as original, in fact, as if they were fashioned by hand in a paint-splattered studio. Moreover, as I mentioned, these originals are gorgeous. If Paine, who remains something of a provocateur, is taking on and subverting whole genres of painting, he is doing the same thing to what he's called standardized "corporate culture" in which automated machines make things over and over, better and better. He has effectively infiltrated the whole arena of product development and manufacturing, not to make a standardized, readily marketable product, but instead to create complex objects packed with multiple suggestions and associations.

That's what happens with the painting machines, and the same goes for Paine's *SCUMAKS* (his sculpture-making machines) and *Drawing Machine* (pp. 60–61). Paine's *Scumak* sculptures, once again computer programmed, are made when a spigot pours liquid blobs of hot polyethylene (not a pleasant material to consider) down onto a conveyor belt (fig. 23). Each layer settles and cools before the next layer is added, and the final sculpture consists of however many layers were programmed. The shape of the sculptures is determined by exactly what the materials do when they are allowed to interact, and the array of forces that factor in is impressive, including gravity, evaporation, humidity, surface tension, and thermal dynamics. Essentially, under the guise of total control, Paine creates a situation that allows for complex interactions to take place without his control. If the results are a series of slightly droopy Mini-malist sculptures that have a vaguely alien look and a hint of dessert confections, so much the better.

Paine's *Drawing Machine* is a large, horizontal device in which a nozzle, attached to various ink bottles, moves across a large sheet of paper on a track system. Periodically, according to the computerized instructions, it dribbles

droplets of ink on the paper and then stops, waiting for the ink to dry. Recently I saw a drawing in process, one that will take months to complete (allegedly designed to be labor-saving and time-saving devices, Paine's machines are actually the exact opposite: they require a huge amount of labor to develop and implement, and the works they produce require an enormous amount of time). The drawing consists solely of the word "damn" repeated over and over (p. 58). As the ink drips and as the repetitions of this word slowly increase, the whole work takes on the look of topography seen from on high, a kind of bird's-eye view of some splendid vista. Sometimes the word is clearly visible. At other times, depending on how the ink has spread and dried, it's more purely abstract. In many instances, it's entirely unrecognizable as a word. Like all of Paine's machines, a hyper-control gives way to a total lack of control. The ink drips and spreads according to its own physics, and it becomes impossible to predict exactly what the finished drawing will look like. The machine sets in motion a process, a slow-moving catharsis. The one thing you can be sure about is that the frustrated source for this work, namely the repeated word "damn," will be completely transformed in the end, and in fact transcended.

4 A few weeks ago, I visited Paine at a cavernous site in Red Hook, Brooklyn, where he and a team of assistants were hard at work on a towering tree made out of stainless steel (fig. 11). On one side of the studio were the raw materials, namely piles of stainless steel pipes and tubing. This is industrial stuff, but it's also the stuff of classic Minimalism, although Paine, once again an inveterate questioner and scrambler of categories and hierarchies, was doing a most un-Minimalist thing, by transforming this steel into a very convincing representation of nature. In the middle of the studio, there was the sprawling, half-finished tree, replete with thick trunk, branches, twigs, and hundreds of welded joints—a breathtaking work, even in its half-completed state.

Now the completed tree has been installed in Central Park in New York (p. 71). I mentioned before a contemporary nature-based sublime, and here it is. From a distance, Paine's tree (called *Bluff*) shines with a luminous dazzle. It's mundane (one more tree in a place full of trees), but also science fictive and bizarre, hinting at homemade rockets and the rattling Tin Man from the Wizard of Oz. Being a constructed thing itself, a kind of nature machine, it responds to the looming buildings that surround Central Park, while also calling attention to just how constructed nature is in its vicinity, where every copse and dell, every path and elm was designed by Frederick Law Olmsted for a reason. Moreover, it's a dead tree, from the leafless look of it, but a dead tree that will survive for centuries. But what really stays with you is the inordinate beauty of this silvery tree, which bedazzles and transforms, evoking exactly the kind of exhilaration and upsweep that Emerson once summoned from his own encounters with nature now quite some time ago.

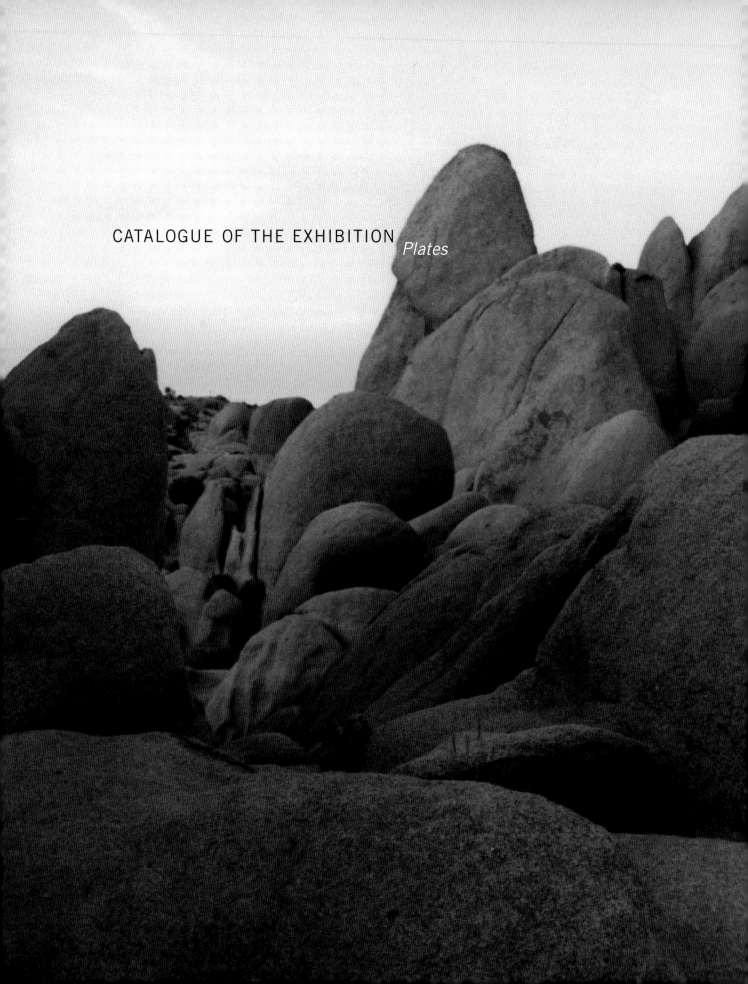

CATALOGUE OF THE EXHIBITION *Plates*

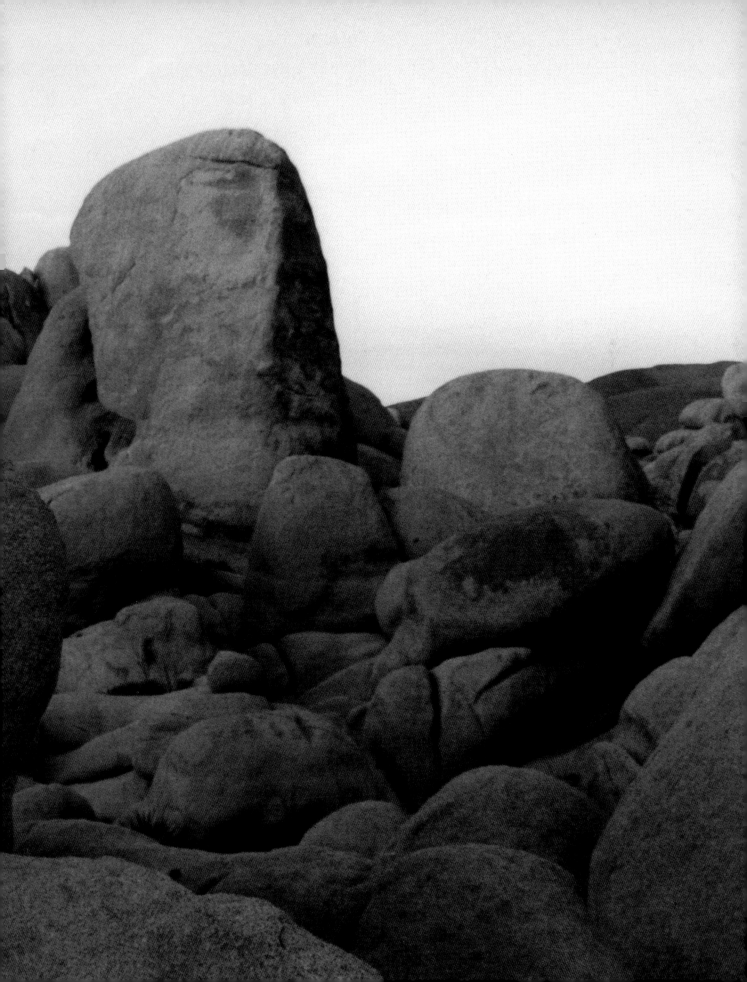

CATALOGUE OF THE EXHIBITION

All works are courtesy the artist and James Cohan Gallery, New York, unless otherwise indicated. Dimensions are listed with height preceding width preceding depth.

MODEL PAINTING, 1996
Polymer, mahogany case, pins and Plexiglas
61 x 85 x 5 inches
Private Collection; courtesy Ronald Feldman Fine Arts,
New York

POISON IVY FIELD (Toxicodendron radicans), 1997
PETG, thermoset polymer, vinyl, lacquer, oil paint, earth, sticks,
stones, and Plexiglas
41 x 48 x 66 inches

CROP, 1997–98
PETG, thermoset polymer, vinyl, lacquer, epoxy, oil paint, earth,
and Plexiglas
58 x 96 x 72 inches
Private Collection, New York; courtesy James Cohan Gallery,
New York

BLOB CASE (No. 8), 1998
Acrylic lacquer, insect pins, and mahogany case
48 x 72 x 6 inches
Collection Jeanette Kahn, New York

PMU (Painting Manufacture Unit), 1999–2000
Aluminum, stainless steel, computer, electronics, motors, pump,
valves, and acrylic paint
110 x 157 x 176 inches

> PMU No. 7, 2001
> Acrylic on canvas
> 36 x 59 x 4 inches
> (Contemporary Arts Museum only)

> PMU No. 8, 2002
> Acrylic on canvas
> 36 x 59 x 4 inches
> (Contemporary Arts Museum only)

pp. 38–39: Joshua Tree National Park in southern California,
photograph by Roxy Paine.

ABSTRACT No. 6, 2000
Fiberglass and oil paint
35 x 48 x 4 inches

AMANITA FIELD, 2001
Polymer, steel, lacquer, and oil paint
48 x 70 x 20 inches
Collection Charles Betlach II

AMANITA VIROSA WALL (Large), 2001
Thermoset plastic, stainless steel, lacquer, and oil paint
155 x 240 x 8 inches
Courtesy the artist and Christopher Grimes Gallery,
Santa Monica

DRAWING MACHINE, 2001
Aluminum, stainless steel, glass, computer, electronics, motors,
valves, paper mounted on aluminum, and ink
90 x 94 x 94 inches

> DM No. 2, 2001
> Ink on paper mounted on aluminum
> 39⅜ x 58¾ inches
> (Contemporary Arts Museum only)

> DAMN B, 2002
> Ink on paper mounted on aluminum
> 39⅜ x 58¾ inches
> (Contemporary Arts Museum only)

DRY ROT, 2001
Fiberglass, epoxy, lacquer, and oil paint
68 x 90 x 8 inches
Collection Robert Conn and Ann Hoger

SCUMAK No. 2, 2001
Aluminum, computer, conveyor, electronics, extruder, stainless
steel, polyethylene, and Teflon
90 x 276 x 73 inches

> Scumaks S2-P2-B1 through B-13, 2002
> Linear low-density polyethylene
> Approximately 18 x 16 x 10 inches each
> (created at The Rose Art Museum and exhibited
> at the Contemporary Arts Museum)

SULPHUR SHELF WALL, 2001
Thermoset plastic, stainless steel, lacquer, oil paint, and epoxy
155 x 292 x 7 inches
Courtesy the artist and Christopher Grimes Gallery,
Santa Monica

Model for LONDON TREE, 2002
Stainless steel
47 x 43 x 43 inches
(Contemporary Arts Museum only)

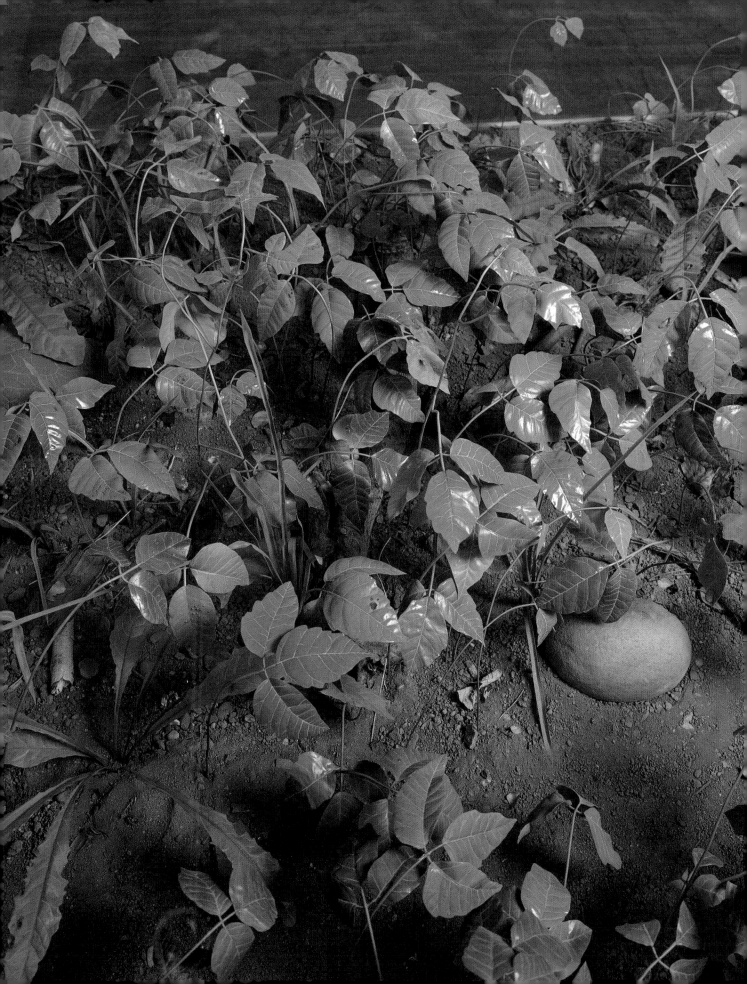

POISON IVY FIELD (Toxicodendron radicans), 1997,
detail and installation view

pp. 44–45: CROP, 1997–98, detail

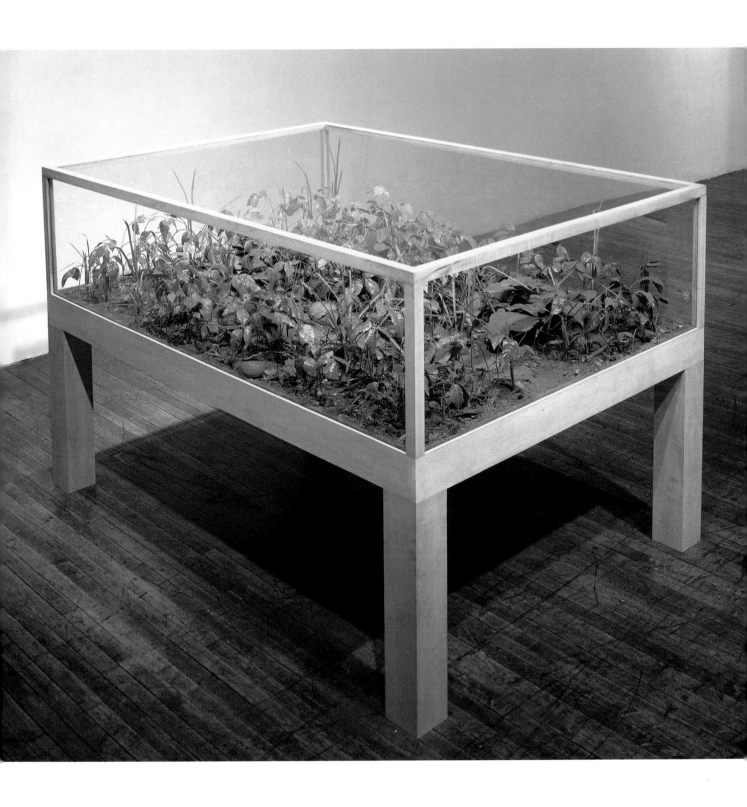

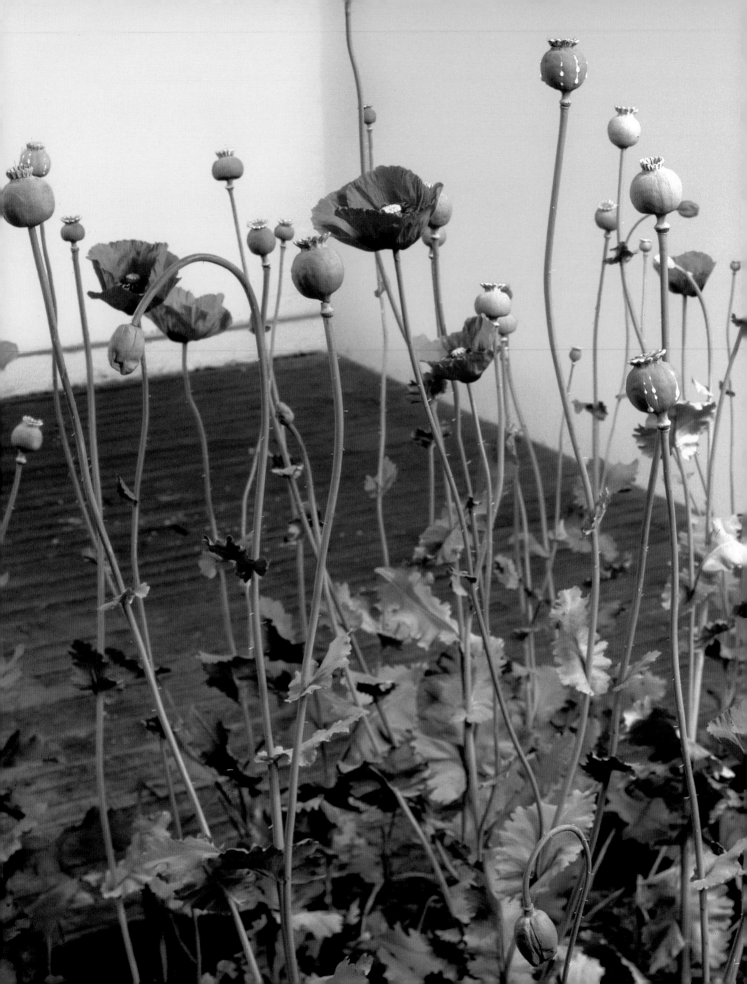

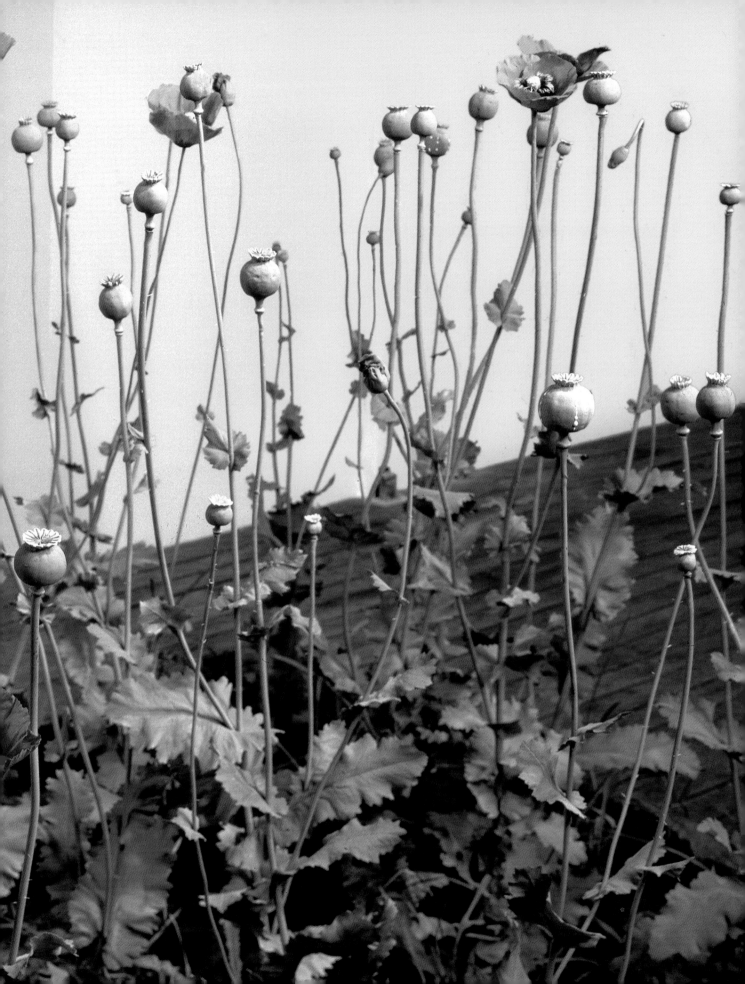

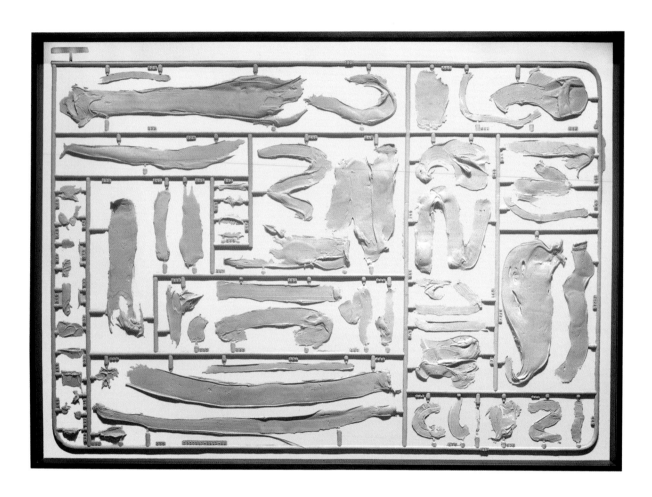

MODEL PAINTING, 1996

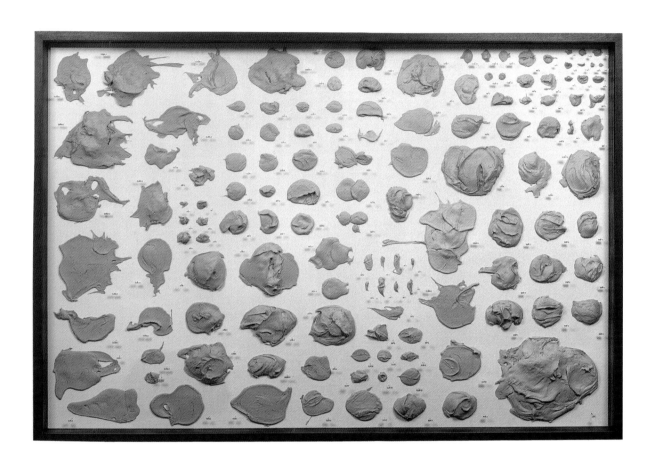

BLOB CASE (No. 8), 1998

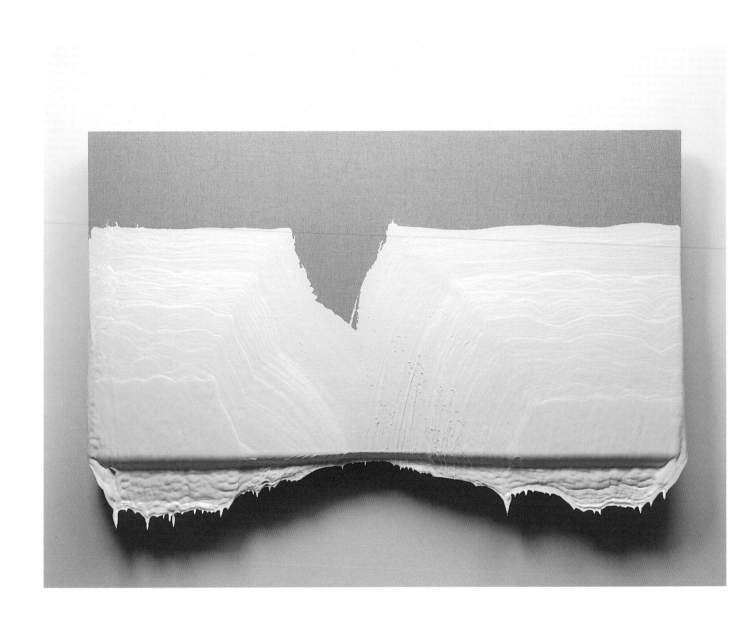

PMU No. 7, 2001

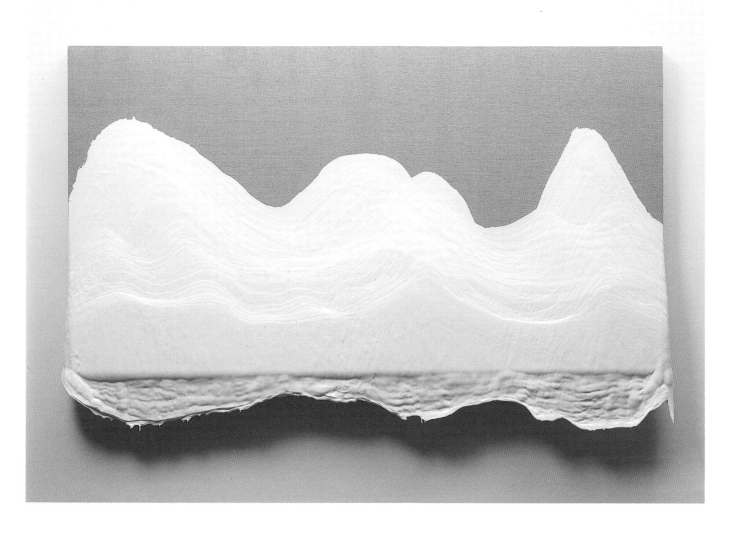

PMU No. 8, 2002

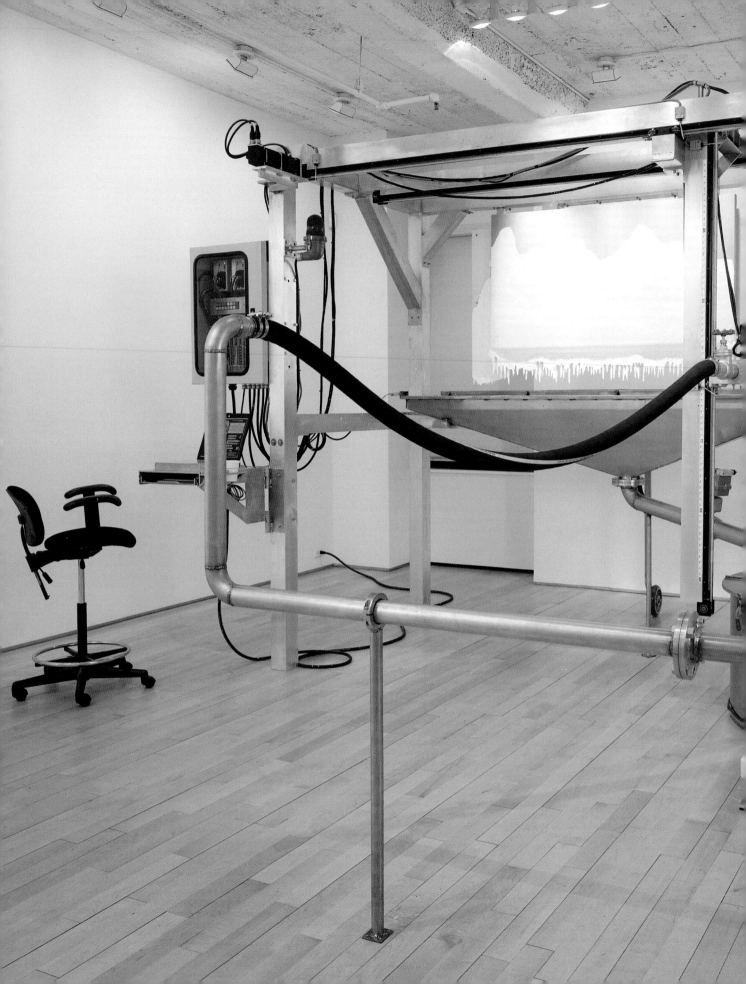

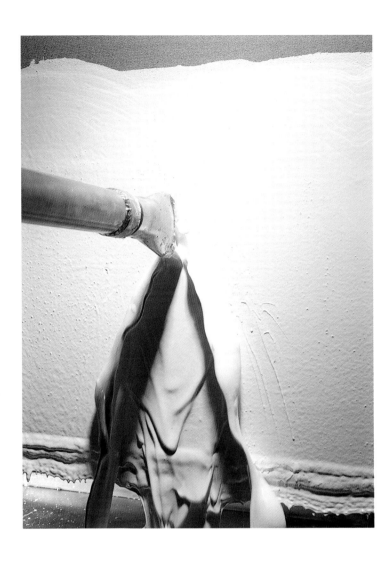

51

PMU (Painting Manufacture Unit), 1999–2000, installation view and detail

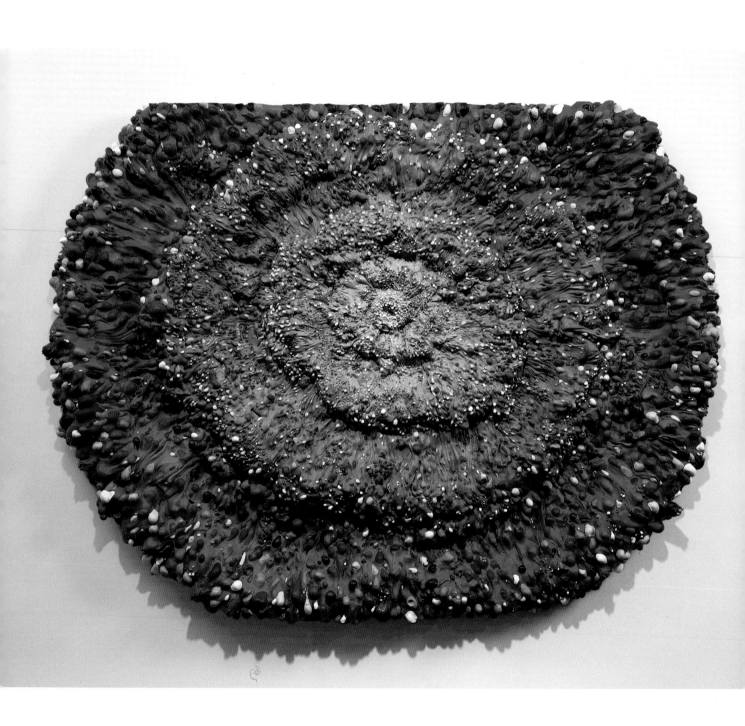

ABSTRACT No. 6, 2000

DRY ROT, 2001, detail (*see also fig. 8*)

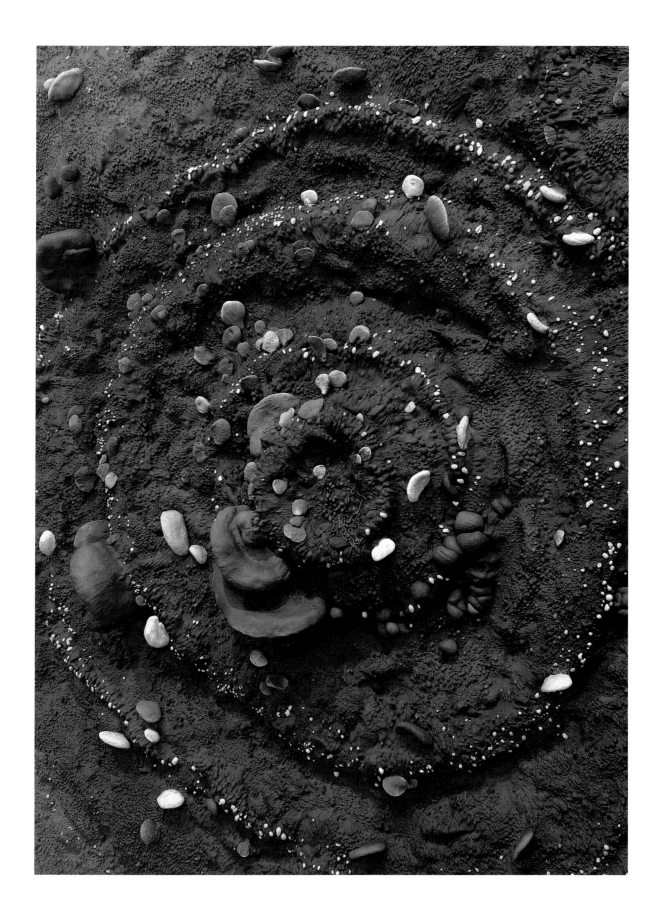

AMANITA MUSCARIA FIELD, 2000, detail

AMANITA FIELD, 2001

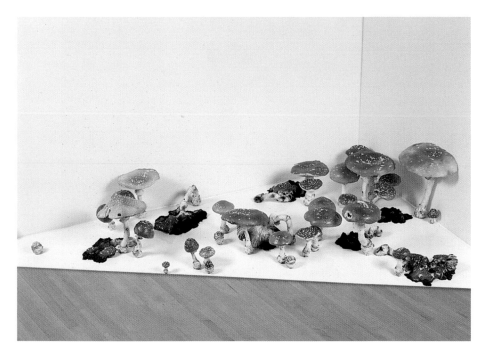

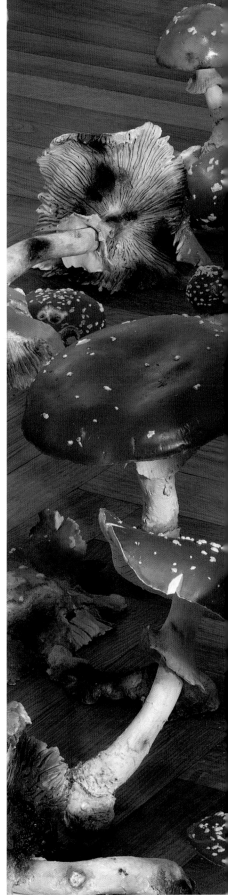

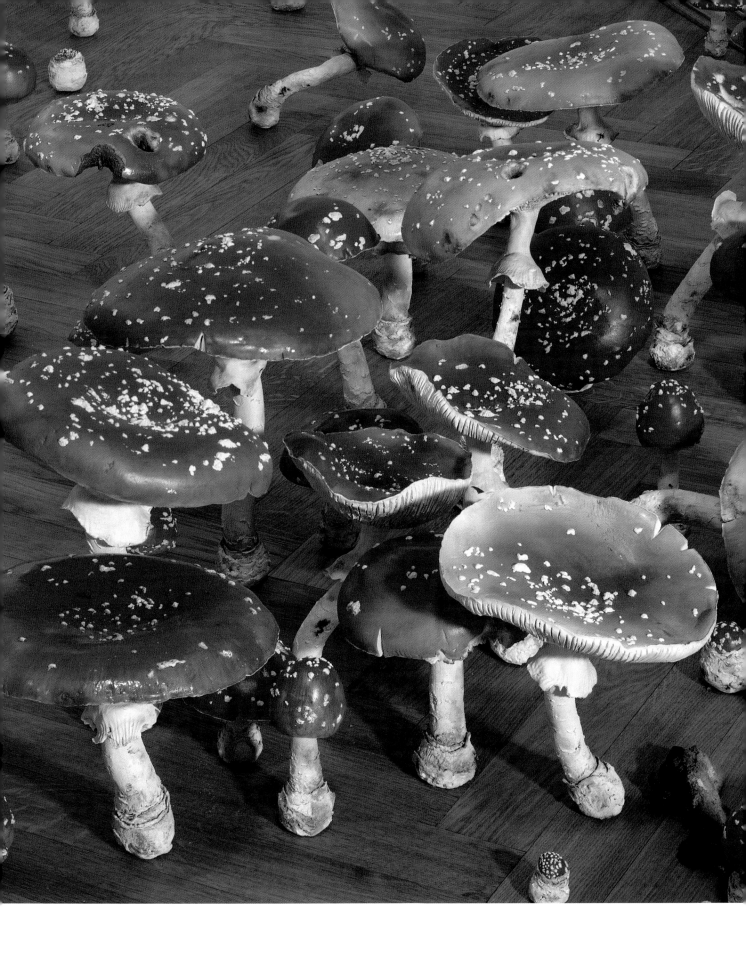

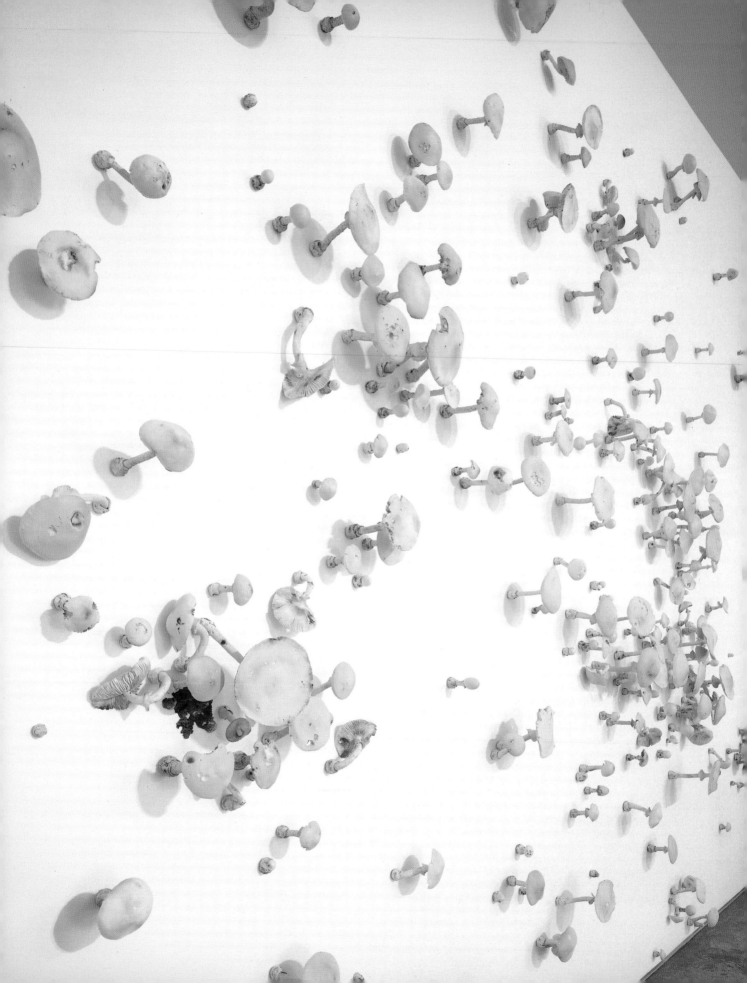

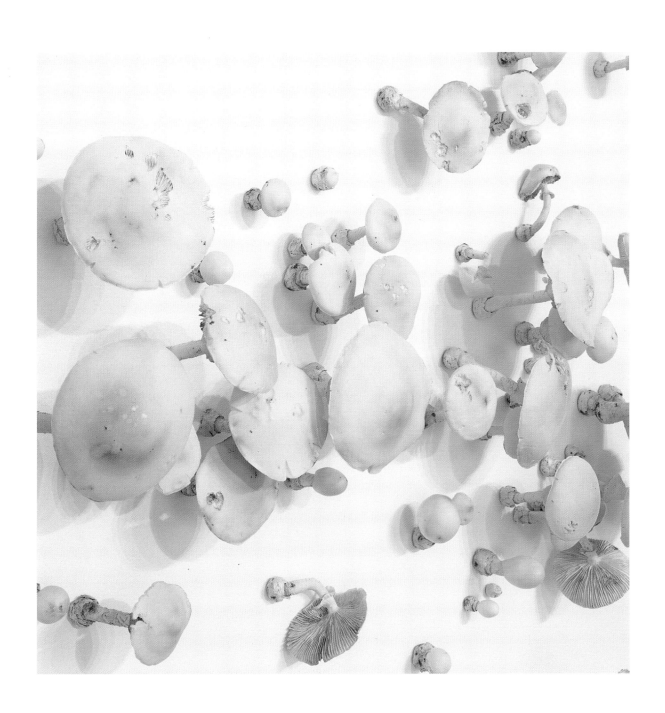

AMANITA VIROSA WALL (Large), 2001, installation view and detail

DAMN B, 2002

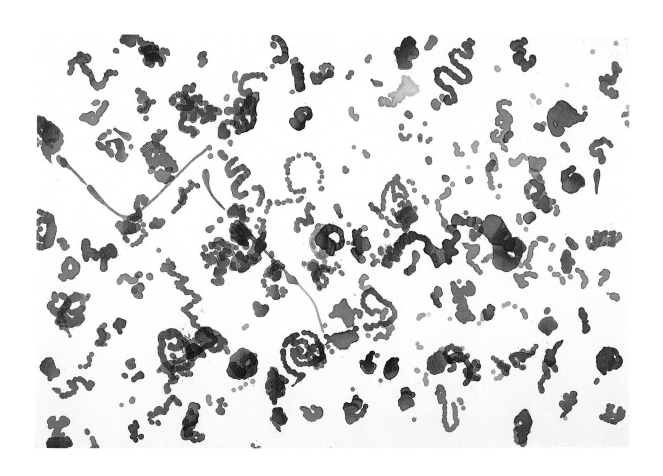

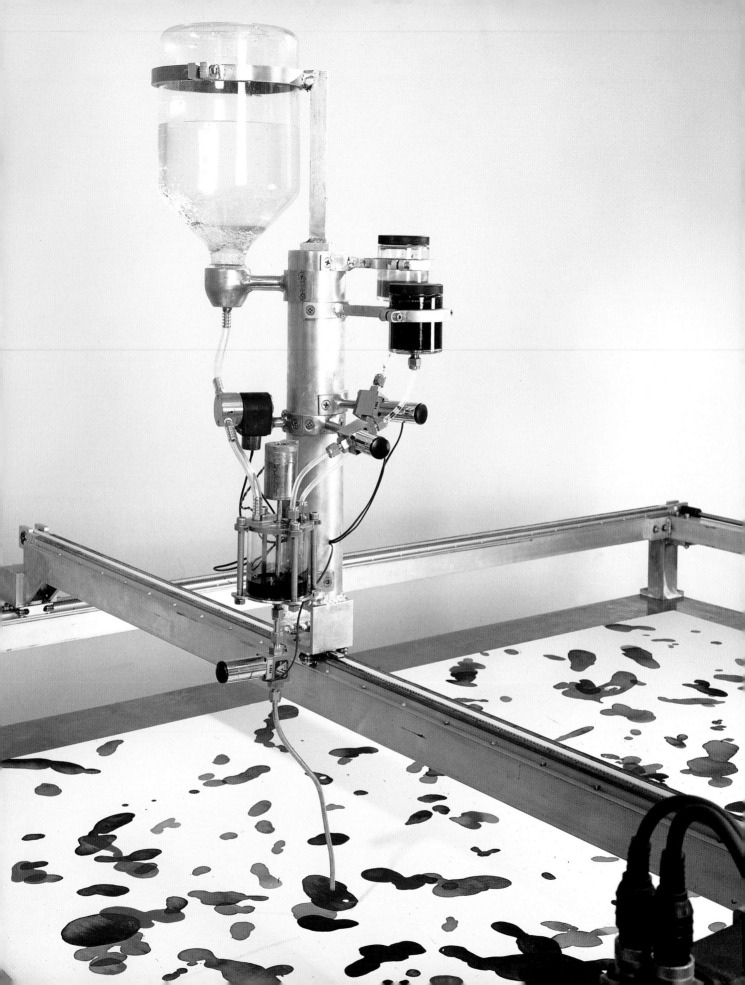

left and below: DRAWING MACHINE, 2001

right: Computer screenshot of program for DAMN B, 2001
(*drawing illustrated on p. 58*)

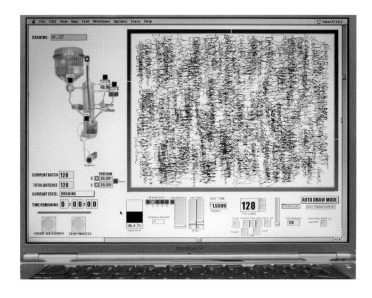

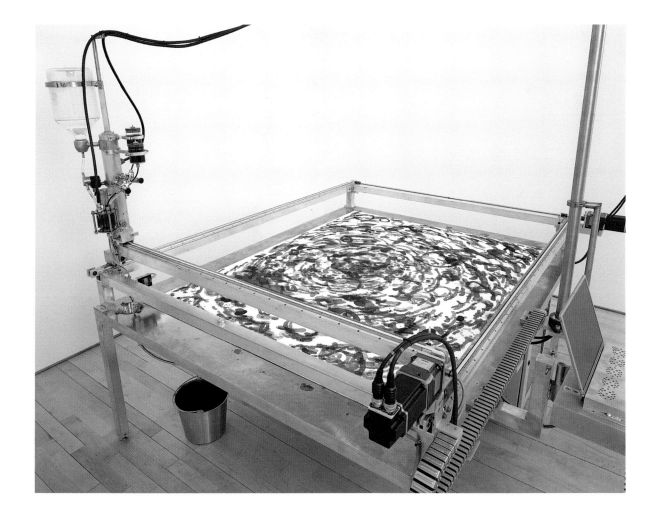

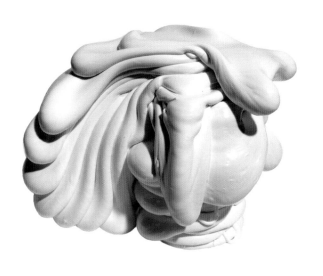
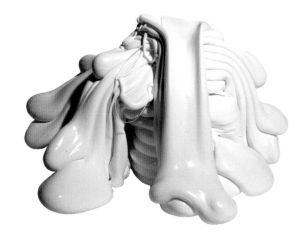
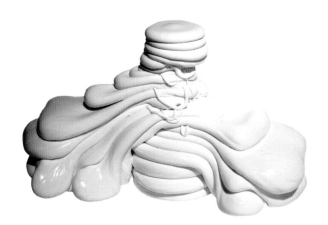
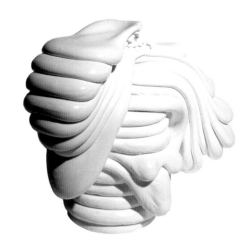

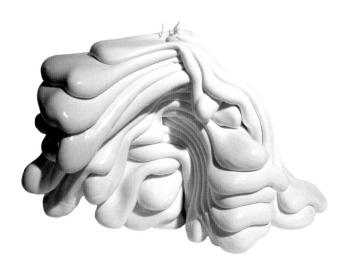
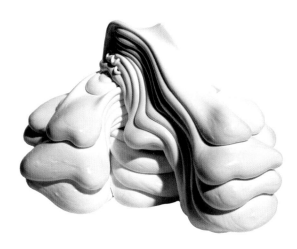

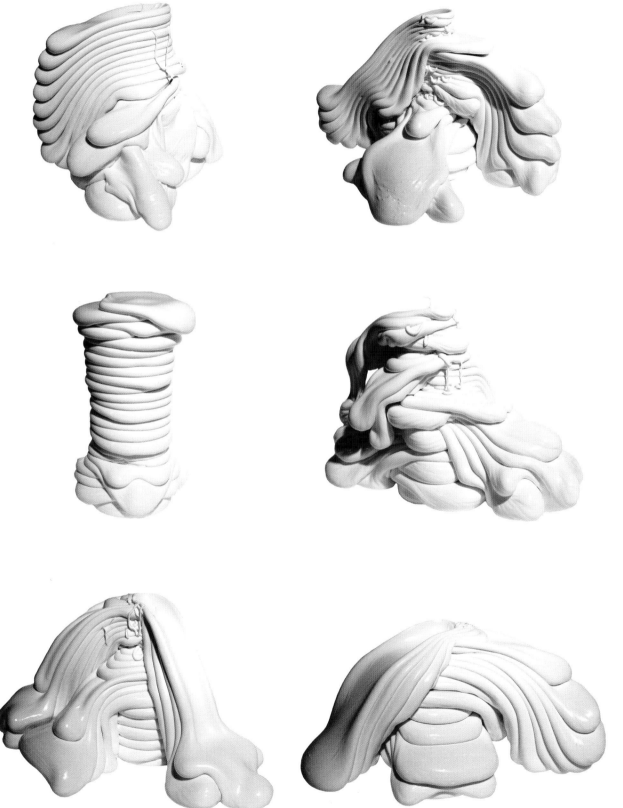

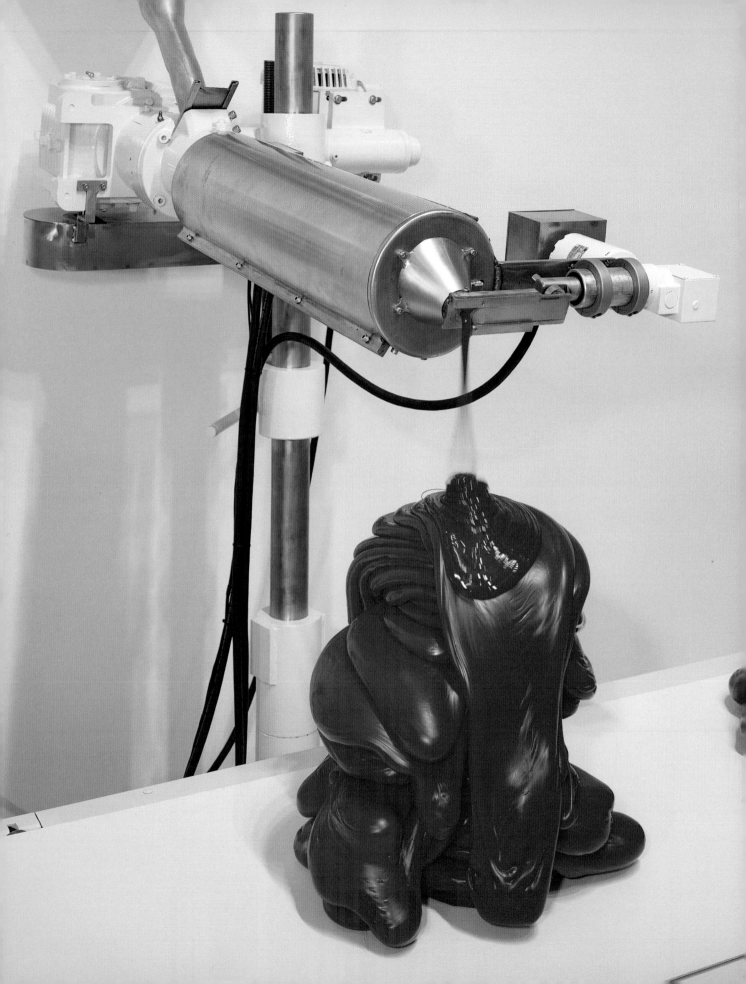

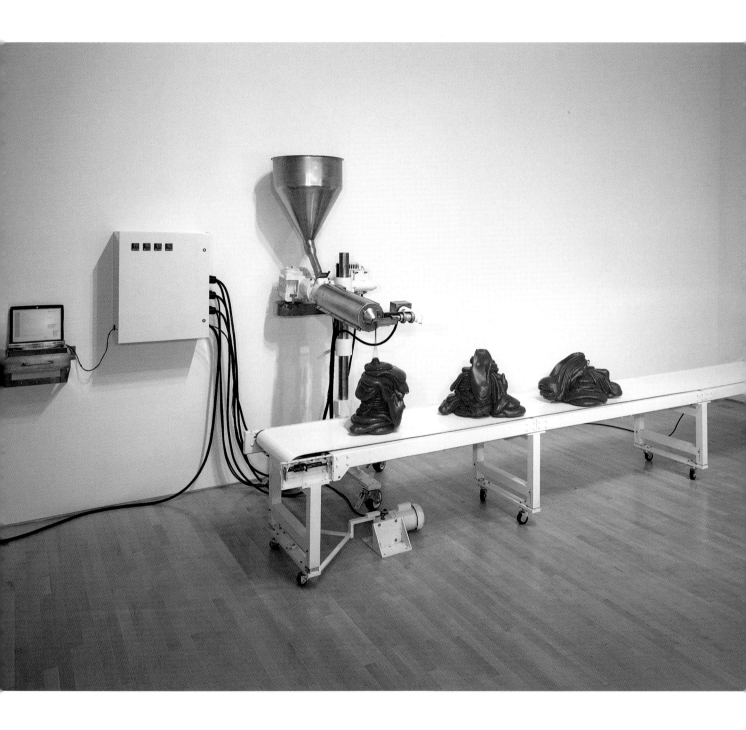

pp. 62–63, left to right, top to bottom:
Scumaks S1-P2-W1, W10, W33, W2, W34,
W14, W31, W38, W11, W15, W24, W20

opposite and above: SCUMAK No. 2, 2001

p. 66, left to right, top to bottom:
Scumaks S2-P2-R32, R17, R28, R45

p. 67: Scumak S2-P2-R51

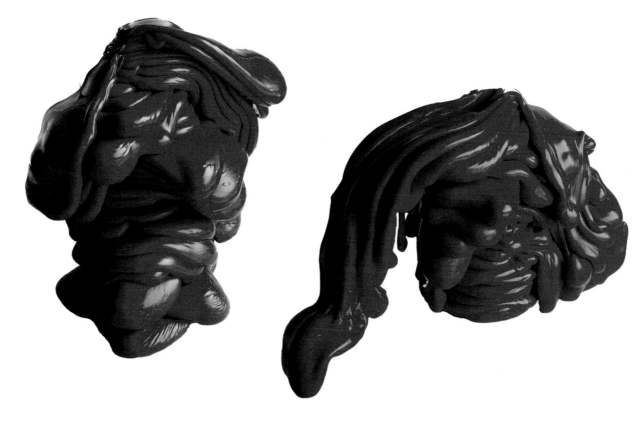

66

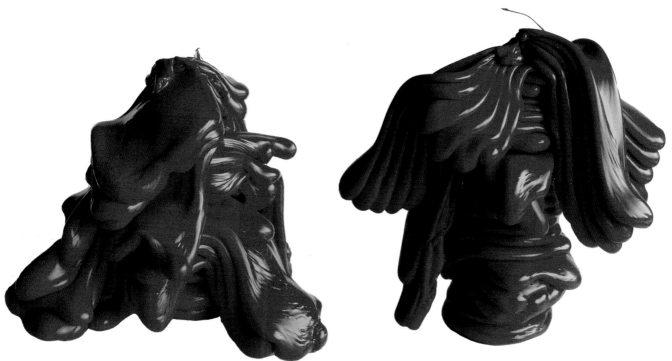

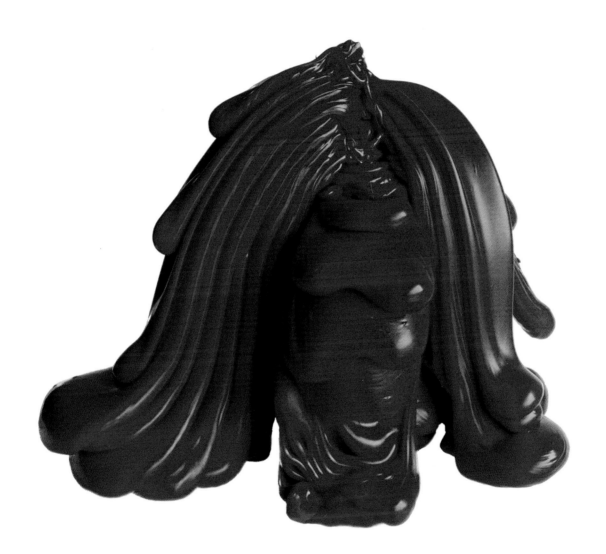

SULPHUR SHELF WALL, 2001, detail and installation view

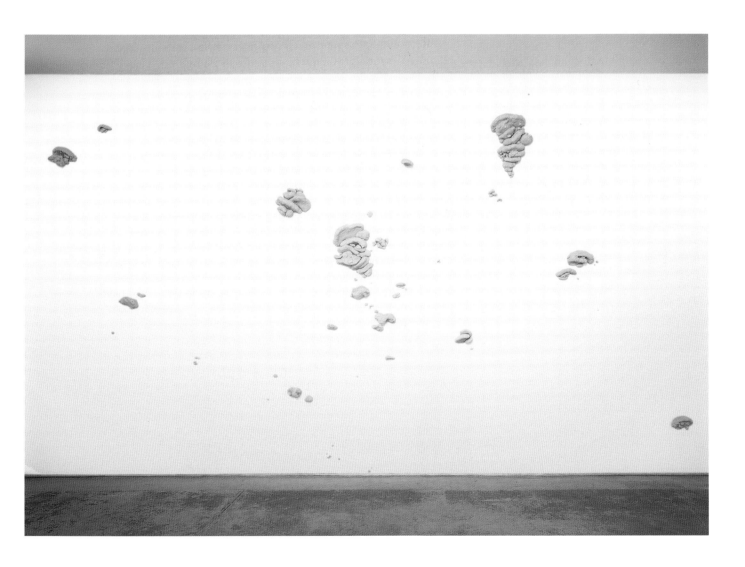

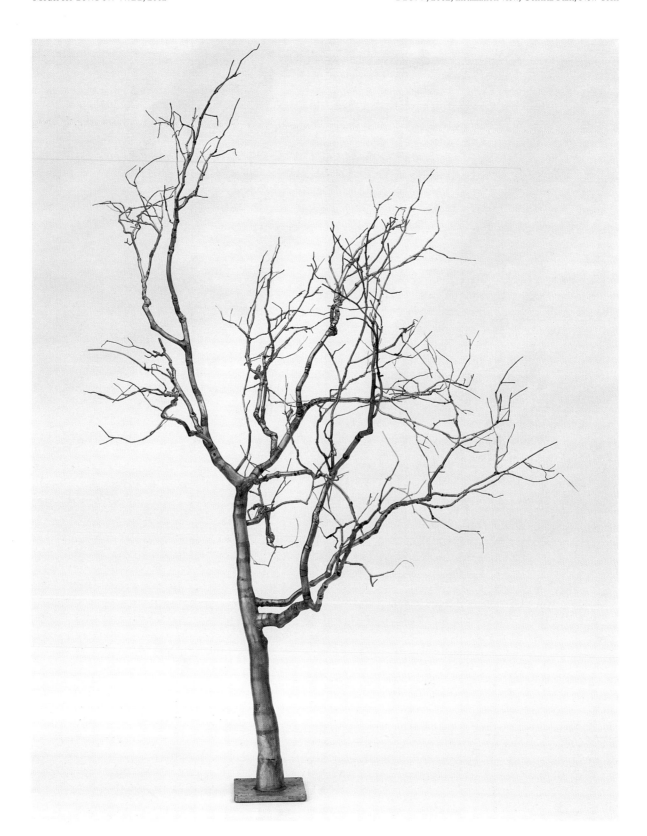

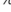

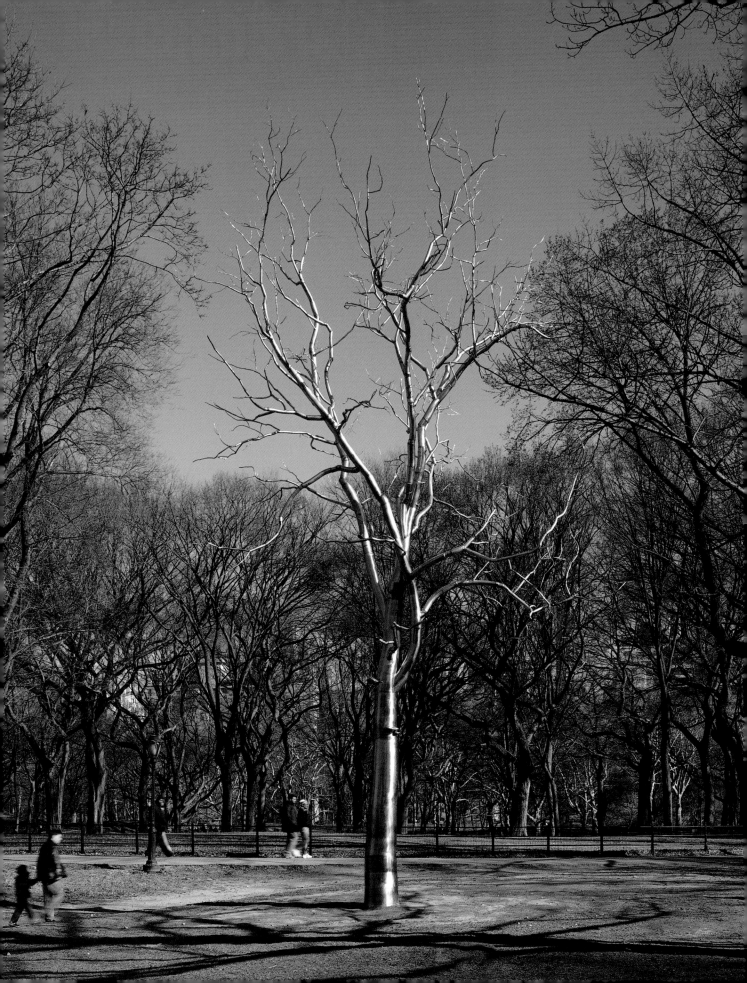

Born 1966, New York, New York
1986–87, College of Santa Fe, Santa Fe, New Mexico
1987–89, Pratt Institute, New York
Lives and works in Brooklyn, New York

SELECTED SOLO EXHIBITIONS

1991

Horns, The Knitting Factory, New York, December 3–31

1992

Roxy Paine, Herron Test-Site, Brooklyn, New York, October 9–
November 8

1995

Roxy Paine, Ronald Feldman Fine Arts, New York, April 29–
June 3

1997

Roxy Paine, Ronald Feldman Fine Arts, March 15–April 26

Roxy Paine, Temple Gallery, Tyler School of Art, Temple University, Philadelphia, September 5–October 11

1998

Roxy Paine, Renate Schröder Galerie, Cologne, Germany,
April 24–June 6

Roxy Paine, Musée D'Art Américain Giverny, Giverny, France,
June 23–November 1. Traveled to Lunds Konsthall, Lund,
Sweden, March 6–April 18, 1999 (catalogue)

1999

Roxy Paine, Ronald Feldman Fine Arts, New York, January 9–
February 13

Roxy Paine, Roger Björkholmen Gallery, Stockholm, Sweden,
February 26–March 31

2001

Roxy Paine, James Cohan Gallery, New York, April 5–May 5
(catalogue)

Roxy Paine: Amanita Fields, Galerie Thomas Schulte, Berlin,
Germany, February 7–April 20

Roxy Paine, Christopher Grimes Gallery, Santa Monica, California, May 26–June 30

Roxy Paine, Grand Arts, Kansas City, Missouri, June 29–August
11

Roxy Paine, Museum of Contemporary Art, North Miami,
Florida, November 11, 2001–January 27, 2002

SELECTED GROUP EXHIBITIONS

1990

Roxy Paine & David Fasoldt, Brand Name Damages, Brooklyn, New York, March 29–April 16

Group Show, Ridge Street Gallery, New York, September 3–September 26

Desire and Deception, Brand Name Damages, Brooklyn, New York, October 9–October 21

1991

The Ego Show, Minor Injury, Brooklyn, New York, April 5–May 2

Tweeking the Human, Brand Name Damages and Minor Injury Galleries, Brooklyn, New York, June 7–June 31

Entropy, Generator 547, New York, August 2–September 5

Group, Jimenez Algus Gallery, Brooklyn, New York, September 13–October 13

1992

Fever, Exit Art, New York, December 12–January 30, 1993

1993

Out of Town: The Williamsburg Paradigm, Krannert Art Museum, University of Illinois, Champaign, Illinois, January 22–February 28 (catalogue)

The Nature of the Machine, Chicago Cultural Center, Chicago, April 3–May 30 (catalogue)

Outside Possibilities '93, The Rushmore Festival at Woodbury, Woodbury, New York, June 5–July 4

Popular Mechanics, Real Artways, Hartford, Connecticut, June 19–July 16

Extracts, Islip Art Museum, Islip, New York, August 8–September 19

Fantastic Wanderings, Cummings Art Center, New London, Connecticut, October 9–November 10

4 Walls Benefit, David Zwirner Gallery, New York, November

INFLUX, Gallery 400, Chicago, November 3–December 4

UNTITLED (14), Ronald Feldman Fine Arts, New York, November 13–December 23

1994

Free Falling, Berlin Shafir Gallery, New York, January 22–February 19

Garden of Sculptural Delights, Exit Art/The First World, New York, March 12–April 23

Spring Benefit, Sculpture Center, New York, April 19

Red Windows: Benefit for the Little Red School House, Barney's Windows, New York, November–December

1995

Art on Paper, Weatherspoon Art Gallery, The University of North Carolina, Greensboro, North Carolina, November 12–January 21, 1996 (catalogue)

Imaginary Beings, Exit Art/The First World, New York, December 2–January 27, 1996

Multiples, Pierogi 2000, Brooklyn, December 2, 1995–January 15, 1996

Lookin' Good-Feelin' Good, 450 Broadway Gallery, New York, December 5–December 9

1996

New York, NY, Withdrawing, Ronald Feldman Fine Arts, New York, January 13–February 17

NY, New York State Biennial, New York State Museum, Albany, New York, February 8–May 26

Better Living Through Chemistry, Randolph Street Gallery, Chicago, March–April

Wish You Were Here, Bronwyn Keenan Gallery, New York, March 1–30

Human/Nature, The New Museum of Contemporary Art, New York, April 20–May 18

Inside: The Work of Art, California Center for the Arts, Escondido, California, June 16–October 13

Currents in Contemporary Art, Christie's East, New York, July 22–July 31

Inside Out, Momenta Art, Brooklyn, New York, September 15–October 7

1997

Benefit For Pat Hearn, Morris-Healy Gallery, New York, February 26–March 9

Artists Respond to 2001: Space Odyssey, Williamsburg Art and Historical Society, Brooklyn, New York, June 21–July 26

Summer of Love, Fotouhi Gallery, New York, July 2–August 2

Sculpture, James Graham & Sons, New York, July 10–August 29

Current Undercurrent: Working in Brooklyn, Brooklyn Museum of Art, Brooklyn, July 25–January 25, 1998

Best of the Season: Selected Work from 1996-97 Gallery Exhibitions, The Aldrich Museum of Contemporary Art, Ridgefield, Connecticut, September 14–January 4, 1998 (catalogue)

9 to 5 at Metrotech: New Commissions for the Common, The Public Art Fund, Brooklyn, October 30–May 31, 1998

Redefinitions, *A View From Brooklyn*, California State University, Fullerton, California, November–December 11 (catalogue)

1998

Landscapes, Meyerson & Nowinski, Seattle, Washington, January 8–March 1

Nine International Artists at Wanås 1998, Wanås Foundation, Knislinge, Sweden, May 24–October 18

DNA Gallery, Provincetown, Massachusetts, July 17–August 5

Flora, Elise Goodhart Fine Art, Sag Harbor, New York, July 24–August 16

22/21, Emily Lowe Gallery/Hofstra Museum, Hempstead, New York, September 8–October 25.(catalogue)

Interlacings: The Craft of Contemporary Art, Whitney Museum of American Art at Champion, Stamford, Connecticut, September 10–November 21

1999

Best of the Season: Selected Work from the 1998–99 Gallery Season, The Aldrich Museum of Contemporary Art, Ridgefield, Connecticut, September 26–January 9

2000

Visionary Landscape, Christopher Grimes Gallery, Santa Monica, California, January 8–February 19

The End, Exit Art/The First World, New York, January 29–April 8

As Far As the Eye Can See, Atlanta College of Art Gallery, Atlanta, Georgia, January 29–March 7 (catalogue)

Greater New York: New Art in New York Now, P.S. 1 Contemporary Art Center, Long Island City, New York, in collaboration with The Museum of Modern Art, New York, February 27–April 16

Sites Around the City: Art and Environment, Arizona State University Art Museum, Tempe, Arizona, March 4–June 4

The Greenhouse Effect, Serpentine Gallery, London, April 4–May 21

Vision Ruhr, Dortmund Coal Factory, Dortmund, Germany, May 11–August 20

Working in Brooklyn: Beyond Technology, Brooklyn Museum of Art, Brooklyn, New York, July 1–September 12

5th Lyon Biennale of Contemporary Art: Sharing Exoticism, Lyon, France, June 27–September 24

WILDflowers, Katonah Museum of Art, Katonah, New York, July 18–October 3

From a Distance: Approaching Landscape, Institute of Contemporary Art, Boston, Massachusetts, July 19–October 8

2001

Making the Making, Apex Art, New York, January 5–February 3

A Contemporary Cabinet of Curiosities–Selections from Vicki and Kent Logan Collection, California College of Arts and Crafts, San Francisco, California, January 17–March 3 (catalogue)

Give and Take, Serpentine Gallery, London, in collaboration with Victoria and Albert Museum, London, January 30–April 1

All-Terrain, Contemporary Art Center of Virginia, Virginia Beach, Virginia, February 22–April 29

01.01.01: Art in Technological Times, San Francisco Museum of Modern Art, San Francisco, California, March 3–July 8 (catalogue)

Present Tense 6, Israel Museum, Jerusalem, Israel, May–December

Waterworks: U.S. Akvarell 2001, Nordiska Akvarellmuseet, Skarham, Sweden, May 19–September 2

Arte y Naturaleza, Montenmedio Arte Contemporaneo, NMAC, Cadiz, Spain June 2–October 2

Brooklyn!, Palm Beach Institute of Contemporary Art, Palm Beach, Florida, September 4–November 25

2002

2002 Biennial Exhibition, Whitney Museum of American Art, New York, March 7–May 26

1990

Blake, Kit. "Review." *Word of Mouth* (September): p. 5.

1991

Sellers, Terry. "Review." *Artist Proof* (Fall): pp. 4–6.

1992

Egert, Robert. "Roxy Paine at Test-Site." *Breukele 1* (January).

Hess, Elizabeth. "Give Me Fever." *The Village Voice*, December 29, p. 95.

Kimmelman, Michael. "Promising Start at a New Location." *The New York Times*, December 18.

1993

Bulka, Michael. "The Nature of the Machine." *New Art Examiner* (September): pp. 30–31.

Davis, Douglas. *The Nature of the Machine: An Exhibition of Kinetic and Biokinetic Art*. Exh. cat. Chicago: Chicago Cultural Center.

Fineberg, Jonathan D. *Out of Town: The Williamsburg Paradigm*. Exh. cat. Champaign, Ill.: Art Museum, University of Illinois.

Robinson, Julia. "Flesh Art." *World Art* (November).

Smith, Roberta. "Examining Culture Through Its Castoffs." *The New York Times*, November 28, pp. 39, 44.

Zimmer, William. "How Physics Is Raised to Metaphysics in a Real Art Ways Show in Hartford." *The New York Times*, July 4.

1994

Larson, Kay. "The Garden of Sculptural Delights." *New York*, March 28.

Levin, Kim. "Choices." *The Village Voice*, April 5, p. 73.

"1993 in Review: Alternative Spaces." *Art in America* 82, no. 8 (August): p. 34.

Wallach, Amei. "An Exuberant Celebration of Life." *New York Newsday*, April 1.

1995

"Also of Note." *The New York Times*, May 19, p. C28.

"Check It Out." *The Print Collector's Newsletter*, 27, no. 5 (November–December): p. 177.

Clarke, Donna. "Chowing with Mao." *New York Post*, May 1, p. 23.

Drucker, Johanna. "The Next Body: Displacements, extensions, relations." *Les Cahiers du Musée National d'art moderne* (Spring).

Fineberg, Jonathan. *Art Since 1940: Strategies of Being*. Englewood Cliffs, N.J.: Prentice Hall.

Heartney, Eleanor. "Roxy Paine at Ronald Feldman." *Art in America* 83, no. 11 (November): pp. 110–111.

Hess, Elizabeth. "Cross Hatching." *The Village Voice*, May 16, p. 86.

Humphrey, Jacqueline. "Art on Paper acquisitions reflect a new Weatherspoon." *Greensboro News & Record*, November 17.

Kocheiser, Tom. *Art on Paper*. Exh. cat. Greensboro, N.C.: Weatherspoon Art Gallery, The University of North Carolina.

Levin, Kim. "Choices." *The Village Voice*, May 16, p. 8.

Light, Flash. "The Neo-Kinetic Closet. "*Movements* 4, no. 1 (Fall): pp. 1, 9–11.

"Sacraments for a Higher Priest." *Harper's*, July, p. 22.

1996

Levin, Kim. "Choices." *The Village Voice*, March 12, p. 8.

Smith, Roberta. "Inside/Out." *The New York Times*, September 20.

1997

"Aldrich gives award to 'emerging' artist." *The Ridgefield Press*, October 23.

Arning, Bill. "Brooklyn in the House." *The Village Voice*, August 26, p. 87.

Baker, Kenneth. "When Reality Is Just Another Medium." *San Francisco Chronicle*, December 23, Datebook.

"Best Do-It-Yourself Art Kits: Roxy Paine." *NY Press Best of Manhattan*, 10, no. 39 (September 24–30): p. 197.

Best of the Season: Selected Works from 1996–1997 Gallery Exhibitions. Exh. cat. Ridgefield, Conn.: The Aldrich Museum of Contemporary Art.

Chaiklin, Amy. "Studio Visits: Roxy Paine." *NY Arts*, no. 14 (October): p. 12.

Dalton, Jennifer. "Just What Do You Think You're Doing Dave?" *Review*, 2, no. 19 (July–August): p. 20.

Dellolio, Peter. "Roxy Paine." *New York Soho* (April): p. 19.

Freedman, Matt, and Annie Herron. *Redefinitions: A View from Brooklyn*. Exh. cat. Fullerton, Calif.: Departmental Association Council and Associated Students.

Gibson, David. "Roxy Paine: Dunk/Redunk: Ronald Feldman Fine Arts." *Zingmagazine*, no. 4 (Summer): pp. 249–50.

Levin, Kim. "Roxy Paine." *The Village Voice*, April 8, p. 13.

Nassau, Lawrence. "Current Undercurrent: Working in Brooklyn." *NY Arts*, no. 14 (October): p. 16.

Pederson, Victoria. "Gallery Go Round." *Paper* (April): p. 54.

Pollack, Barbara. "Buying Smart: Top Collectors Share Their Secrets." *ARTnews*, 96, no. 11 (December): pp. 137–39.

Schmerler, Sarah. "Last exit to Brooklyn." *Time Out New York*, no. 97 (July 31–August 7): p. 40.

Smith, Roberta. "Roxy Paine." *The New York Times*, April 4, p. C28.

1998

Ahistron, Crispin. "Intelligenta naturlekar." *Goteborgs-Posten* (Sweden), June 5, p. 48.

Bonetti, David. "What It Is 'To Be Real.'" *San Francisco Examiner*, January 12, C-1, p. 17.

"Champs artificiels …et machine a peindre." *Eure Inter* (France), July 9.

"Champs artificiels et machine à peindre au Musée d'Art Americain de Giverny." *Le Democrata* (France), July 1.

Cooney, Beth. "The Craft of Art." *The Advocate & Greenwich Time*, October 11.

Costa, Eduardo. "Crafty Contemporanea." *ARTS*, D3.

Fredericksen, Eric. "Landscapes and Suburbs Beyond Nature." *The February Stranger* 5.

Frey, Jennifer. "Lacing Art and Craft into One Form." *Weekend* (September 10–16).

Gignoux, Sabina. "Les jeux ambigues d'une naturelle inspiration." *La Croix* (France) (August).

Glueck, Grace. "A Chair, a Fireplace, Binoculars: Sculpture to be Seen on the Street." *The New York Times*, January 16, p. E39.

Hackett, Regina. "Warmth and Romance Prove Elusive in Meyerson & Nowinski's Landscape." *Seattle Post- Intelligence*, January 9.

"In the Public Realm." *Inprocess* 6, no. 3 (Spring): p. 5.

JK. "An Opium Field–Deceptively Natural." *Kolner City-Observer* (Germany), May 14.

Kyander, Pontus. "Elegant och Intelligent." *Sydvenskam* (Sweden), May 27.

"Les Champs de Roxy Paine." *La Depêche d'Evreux* (France), July 2.

Lind, Ingela. "Naturen som hot." *Dagens Nyheter* (Sweden), July 30.

Morgan, Robert. *22/21*. Exh. cat. Hempstead, N.Y.: Hofstra University.

"Paper Trail." *On Paper* 2, no. 3 (January–February): p. 7.

Schon, Margaretha. "Med freestyle och insiders I Wanås Walk." *Svenska Dagbladet* (Sweden), June 13, p. 13.

Storr, Robert. *Wanås 1998*. Exh. cat. Knislinge, Sweden: The Wanås Foundation.

Updike, Robert. "Beyond Pretty Scenery." *Visual Arts*.

Zimmer, William. "Seven Artists Apply Craft to Fine Art." *The New York Times*, October 11, p. 24.

1999

As Far As the Eye Can See. Exh. cat. Atlanta, Ga.: Atlanta College of Art Gallery.

Bakke, Eric. "Roxy Paine, Studio Visit." *NY Arts (*January): p. 44.

Bakke, Eric, and Shelley Ward. "Mob Rule: Sculpture After Hanson." *NY Arts* (March): pp. 10–13.

Billgren, Cecilia. "Utvecklingsstord lamnades ensam." *Arbetet Nyheterna* (Sweden), March 6.

Burrows, David. "Dunkin' Donuts." *Art Monthly* (March): pp. 6–10.

Ellerstrom, Jonas. "Drogromantik eller kulturkritik?" *Helsingborgs Dagblad* (Sweden), March 22.

Hall, Kim. "Brooklyn-Komstnar pa Lunds konsthall." *Skanska Dagbladet* (Sweden), March 6.

Henry, Max. "Gotham Dispatch." *Artnet Magazine*, http://www.artnet.com/magazine/news/ henry/html.

Johnson, Ken. "Roxy Paine." *The New York Times*, January 15, p. E42.

Jonsson, Dan. "Tur och retur till naturen." *Express* (Sweden), March 25.

Kino, Carol. "Roxy Paine." *Time Out New York* (February 4–11): p. 57.

Kjellgren, Thomas. "Under ytans ordning finns det okontroller bara." *Kristianstedsbladet* (Sweden), March 25.

———. "Tillbaka till naturen: Roxy Paines omsorfgsfulla lekfullhet smittar." *Hallandsposten* (Sweden), March 26.

Klein, Mason. "Roxy Paine." *Artforum* 37, no. 8 (April): p. 123.

Klinthage Lorgen. "Vart behov att beharska naturen." *Arbetet Nyheterna* (Sweden), March 22.

Kyander, Pontus. "Art Gallery filled with unnature." *Sydsvenskan* (Sweden), March 9.

Lautman, Victoria. "No Wedding Necessary." *Interview* (January):, p. 20.

Levin, Kim. "Roxy Paine." *The Village Voice*, January 12, pp. 77–78.

———. "Roxy Paine." *The Village Voice*, January 26, p. 68.

Lin, Tan. "Fungi of False Reproduction." *ArtByte* 2, no. 1 (April–May): p. 64.

Malmqvist, Conny C-A. "Roxy Paine gorett konststycke …" *Kv Kvallsposten* (Sweden), March 16.

Maxwell, Douglas. "Roxy Paine." *Review*, February 1, p. 7.

Multer, Mario. "Roxy Paine." *Review*, February 1, pp. 7–9.

Nahas, Dominique. "Roxy Paine." *Flash Art* 32 (May–June): pp. 114–15.

Nordstrom, Nicklas. "2000 svampar ger eftertanke." *Lund Langlordag* (Sweden), March 6.

Paul, Christiane. *In Vitro Landscape*. Cologne, Germany: Buchandlung Walther Koenig, p. 35.

Pedersen, Victoria. "Gallery Go 'Round: Roxy Paine." *Paper* (February): p. 136.

Pinchbeck, Danie. "Our Choice of Contemporary Galleries in New York." *The Art Newspaper* 89 (February): p. 72.

Schwabsky, Barry. "Surrounded by Sculpture." *Art in America* 87 (January): pp. 56–59.

Strom, Eva. "Nice flowers with chilly undertone." *Svenska Dagbladet* (Sweden), March 13.

Weil, Rex. "Roxy Paine." *ARTnews* (April): pp. 119–20.

2000

Cambell, Clayton. "The Visionary Landscape." *Flash Art* (March–April): p. 62.

Heiss, Alanna. "Greater New York." *NY Arts* (March): pp. 44–45.

Johnson, Ken. "Extra Ordinary." *The New York Times*, June 9, p. E29.

Lineberry, Heather Sealy, and Ronald Jones. *Sites Around the City: Art and Environment.* Exh. cat. Tempe, Ariz.: Arizona State University Art Museum.

Nordlinger, Pia. "Double Dipping." *ARTnews* (March): p. 34.

O'Connel, Kim. "Fungus Among Us." *Landscape Architecture* (March): p. 1.

Saltz, Jerry. "Greater Expectations." *The Village Voice*, March 14, p. 67.

Searle, Adrian. "Stuck in the Woods." *The Guardian*, April 4, pp. 14–15.

Staple, Polly. "The Greenhouse Effect." *Art Monthly* (May): pp. 38–40.

Tumlir, Jan. "The Visionary Landscape." *Frieze* (May): pp. 114–15.

2001

"010101: Roxy Paine." *Wired News*, www.wirednews.com/news/culture/0,1284,42178,00. html, March 2.

Betsky, Aaron, Janet Bishop, Erik Davis, Kathleen Forde, Adrienne Gagnon, David Toop, John S. Weber, and Benjamin Weil. *01.01.01: Art in Technological Times.* Exh. cat. San Francisco: San Francisco Museum of Modern Art.

Goldberg, David. "'010101: Art in Technological Times' at SFMOMA." *Artweek* (May): pp. 12–13.

Hammond, Anna. "Roxy Paine at James Cohan." *Art in America,* September, p. 156.

Hand, Eric. "SF MOMA's '010101': Digital art for analog people." *Stanford Daily*, April 12.

Iannaccone, Carmine. "Roxy Paine at Christopher Grimes Gallery." *Frieze,* September, pp. 93–94.

Knight, Christopher. "Roxy Paine." *The Los Angeles Times.* June 15, p. F26.

Landi, Ann. "The Big Dipper." *ARTnews* (January): pp. 136–39.

Muchnic, Suzanne. "Museum Chief." *The Los Angeles Times,* March 18, pp. 5, 90, and 91.

Rogina, Kresimir. "Izlozaba '010101." *Croatian Daily*, May.

Rothkopf, Scott. *Roxy Paine.* Exh. cat. New York: James Cohan Gallery.

Rugoff, Ralph. *A Contemporary Cabinet of Curiosities–Selections from the Vicki and Kent Logan Collection.* Exh. cat. San Francisco: California College of Arts and Crafts.

_____. "Virtual Corridors of Power." *London Financial Times,* March.

Wachtmeister, Marika. *Arte y Naturaleza.* Exh. cat. Cadiz, Spain: Montenmedio Arte Contemporaneo.

_____. *Konsten pa Wanas [Art at Wanas].* Stockholm: Byggforlaget.

Wertheim, Margaret. "Worlds Apart." *L.A. Weekly*, May 18, p. 37.

2002

Budick, Ariella. "Pieces of the Biennial Take to the Park." *Newsday*, March 6, p. A10.

Vogel, Carol. "A Steel Tree in Central Park? Well, Times Have Changed." *The New York Times*, February 27, pp. A1, A23.

PHOTOGRAPHY

Courtesy the artist: fig. 10

John Berens; courtesy the artist: cover

John Berens; courtesy James Cohan Gallery, New York: pp. 2–3, 5, 44–45, 47–49, 58–59, and 70

Courtesy James Cohan Gallery, New York: p. 54

Dennis Cowley, courtesy the artist: fig. 18

John Lamka, courtesy the artist: figs. 3, 6, 17, 19, 20; and p. 71

John Lamka, courtesy James Cohan Gallery, New York: figs. 1, 7, 12, 21, and 22; pp. 42, 43, 46, and 52

J. Littkemann, Berlin; courtesy James Cohan Gallery, New York: p. 55

Jack Muccigrosso, courtesy the artist: fig. 14; pp. 66–67

Anders Norsell, courtesy James Cohan Gallery, New York: figs. 2 and 9

Bill Orcutt, courtesy James Cohan Gallery, New York: pp. 50, 51, 60, and 61 (bottom)

Frank Oudeman, courtesy the artist: pp. 64–65

Roxy Paine: figs. 5, 13, 15, and 16; pp. 1, 38–39, 61 (top), and 62–63

Seth Rubin, courtesy the artist: fig. 4

Chad Springer, courtesy the artist: fig. 11

Joshua White, courtesy Christopher Grimes Gallery, Santa Monica: fig. 8; pp. 53, 56, 57, and 68–69

CATALOGUE

Publication co-ordinator: Lynn M. Herbert

Editor: Polly Koch

Design: Don Quainance, Public Address Design

Design/production assistant: Elizabeth Frizzell

Typography: Public Address Design, composed in Adobe Caslon (text) and Trade Gothic (display)

Color separations/halftones and printing:
Champagne Fine Printing, Houston